ANDSCAP
OTOGRA

© Derek G. Widdicombe 1987

ISBN 0902 363 62 X

Published 1987

Printed in Great Britain by Martin's of Berwick
and bound by Hunter & Foulis of Edinburgh

Cover Illustration:

Swaledale from Crackpot Hall, Keld, North Yorkshire. *Pentax camera. Ektachrome 64ASA film. 81A filter. 50mm standard lens. June around 2.00pm. Exposure 1/60th at f11.*

One of my favourite Yorkshire Dales - Swaledale. I was tracing out a walk on the Pennine Way towards Muker from Keld for a magazine article. Looking down the dale towards the Muker I noted how the contours of the fields and the lower hillsides created a range of greens through which the infant river Swale wound its course. It epitomised summer in the Dales. The standard lens gave equal weight to the foreground and distance, and kept the detail in the interesting break through the hills in the centre distance in the picture. It just needed the sun to cast the right cloud patterns to bring life to the scene.

Landscape Photography

A PRACTICAL GUIDE

Derek G. Widdicombe

Line illustrations by Janet A. Widdicombe B.Sc. (Architecture)

CICERONE PRESS

MILNTHORPE, CUMBRIA, ENGLAND

TO JANET AND NICOLA

Contents

CHAPTER ONE

Introduction

The first successful photographs were taken by a French naval officer and amateur scientist, Joseph Nicéphore Niépce (1765-1833) in the 1820's. English archaeologist, chemist, linguist and mathematician William Fox Talbot produced the first successful *negatives* in 1834 - and the negative-positive process of photography was born. This process, with various improvements and developments, has remained the basis of most photography to this day.

The history of these early days makes interesting reading, peopled by such names as Daguerre (1787-1851), painter and stage designer, with his Daguerreotype process which John Ruskin looked on favourably as an antidote to 'all the mechanical poison that this terrible 19th century has poured on man'. The later years of the 19th century saw the emergence of many enthusiastic photographers: David Octavius Hill and Robert Adamson made about 2,000 'calotypes' of life in the large cities and small fishing villages of Scotland, whilst Matthew B.Brady recorded the American Civil War. In France, Nadar took the first ever aerial photographs from a balloon in 1858. In England, Julia Margaret Cameron (1815-1879) portrayed the famous people of her day in the converted hen house of her home at Freshwater on the Isle of Wight, whilst University don Lewis Carroll, an enigmatic personality, achieved success with his photographs of children. The countryside around the Yorkshire fishing village of Whitby was portrayed by Frank Meadows Sutcliffe from 1875-1922.

In New York Alfred Stieglitz recorded everyday life in the city in adverse conditions of snow and storm, rain, mist and smoke.

All this artistic activity convinced a critical public that far from the prophecy that 'from today painting is dead' which accompanied the discovery of photography, photography had its own unique artistic

content. Different branches of photography emerged. It became a useful tool for recording scientific phenomena. The human face peered into countless camera lenses. It became obvious that despite the mechanical nature of the process, photography was at the meeting point of science and art. Landscape photography emerged as having the highest artistic content of any branch of photography.

Cameras and films became much simpler in operation. Colour photography resulted from the work of Sir James Clerk Maxwell, du Hauron, Lippmann and the Lumière Brothers. The development by two out-of-work musicians in New York, L.D.Mannes and L.Godowsky, resulted in the introduction of Kodachrome to the public in 1935. By now photography could be completely naturalistic. 'It's only a photograph' became a familiar cry. It has taken many decades of work by dedicated landscape photographers to convince a discerning public that good landscape photography is a supreme art form. Probably the most difficult branch of photography in which to succeed.

In a good landscape photograph everything must 'add up'. All the elements of the picture must blend with each other. The 'rules' of landscape photography can only provide the flimsiest of guidelines. In almost every instance the landscape photographer is thrown back on his sensitive reaction to the scene which unfolds before him. The interaction of colour, form and light must be just right. The correct balance may only be there for a few seconds. That moment must be recognised instantly. It will be a vision which only the photographer has experienced. A privileged view which is passed on through the medium of film to others.

Landscape photography starts with the feet. There is no better way to appreciate the countryside than to don a pair of stout walking shoes or boots. Let those feet take you along river valleys, around lakes, up hillsides and into forests. Trudge through snow and take a shoreline view of the world.

My own introduction to the British countryside was on the hills of Northern England. At a very early age I learnt the exhilaration of a climb to the top of Great Gable in the Lake District. At all levels the views up, down and across were 'filed' away in my mind's eye to be brought out again in later years when I had learnt to master a camera. The other inspiration from those years was the rugged coast of Northumberland. The hard rocks of the intrusive Whin Sill at Bamburgh and Dunstanburgh castles, contrasted with the sheltered activity of the fishing villages. Since then my cameras have

accompanied me to most parts of Britain and many places abroad. But it was in those first years among the northern hills that I acquired the skills that enabled me to earn a living as a professional photographer and writer. Even now, as I frame up a landscape subject abroad, I draw a comparison with some familar view on the Pennines or across a Lake District lake.

My first camera was a simple Box Camera - still around in the family. Since then I have used various cameras and lenses to achieve the results I required. But more and more I come back to the simple formula of two simple cameras - one for colour, one for black/white, a pocket full of film, warm clothing and a pair of strong boots. To that must be added the experience which can only be gained from years of contact with all types of landscape.

This book aims to show in simple terms how to achieve a professional standard in landscape photography. It cuts through a lot of the jargon which stands in the way of a simple understanding of the technicalities of this branch of photography. Above all it aims to make the whole process a pleasurable pursuit, free from complications, leaving the photographer free to enjoy what is at the heart of landscape photography, a love of the world around us.

CHAPTER TWO

The History of Landscape Photography

Landscape photography in Britain has had its peaks and troughs, styles and modes. The first real attempts at artistic landscape photography were in the 1850's. One of the first practitioners was Henry White, a partner in a London firm of solicitors. Roger Fenton (1819-1869) was also trained as a solicitor, before turning to photography as a profession. He was the son of a successful Lancashire mill owner, who sat for a short time as M.P. for Rochdale across the floor from William Fox Talbot, member for Chippenham in Wiltshire. He was the founder and first Honorary Secretary of the Royal Photographic Society (1853) and the first man to photograph war scenes under fire. In February 1855 he sailed from England as accredited photographer for the Crimean War, returning home with over 300 negatives the following year. But Roger's landscape photographs also gained acclaim. The link between the law and photography has been continued in recent years by Sir George Pollock, who abandoned a career in law to become an 'artist photographer', and along the way has been President of the Royal Photographic Society. It must be remembered that Roger Fenton was using collodion plates of a very slow speed for his work. These plates were about the speed of bromide paper and were exposed in the camera whilst still wet. Other names from this period are those of Philip Henry Delamotte, a professor at King's College, Cambridge, water colour artist and landscape photographer, and Robert Macpherson (1811-1872) a Scottish surgeon who eventually settled in Rome to pursue his love of art. Robert is celebrated for his views of Rome.

Also from the 1850's onwards, publishers of view cards sprung up. Francis Frith of Reigate, James Valentine of Dundee and the less well known George Washington Wilson of Aberdeen. George was

Photographer Royal to Queen Victoria whilst she was in Scotland. George can be said to have 'invented' the instantaneous exposure. He would remove the lens cap with one hand, at the same time using his other hand to cover the lens with his glengarry bonnet. This operation resulted in a repeatable exposure of 1/6th of a second, compared to the 45 seconds which Francis Frith employed to enable him to stop his lens well down to achieve a great depth of field.

Francis Frith was a deeply religious man of great energy and his travels took him all over the world, particularly to Egypt and the Holy Land. But it is for his documentation of Britain's towns, villages and cities that he is best remembered. Many of his negatives are in existence today. Some are heavy glass plates. After various fortunes, these priceless negatives have been rescued and copies are available. A business name which still exists today is that of James Valentine of Dundee - I recently visited their premises. His archive, which contained extensive coverage of Scotland, is now held by the University of St. Andrews - including his famous photograph of the Tay Rail Bridge disaster of 1897, when the bridge collapsed in a heavy gale whilst a train was passing over it.

Around the turn of the century came those who specialise in portraying a particular area. Frank Meadows Sutcliffe (1853-1941) has already been mentioned for his portrayal of the North Yorkshire coast around Whitby. Cuban born Dr.Peter Henry Emerson (1856-1936) gave up medicine in 1885 for writing, and the photography of life in East Anglia and the Norfolk Broads. His most famous book was 'Life and Landscape on the Norfolk Broads' (1886). He was known as the father of Naturalistic Photography. He was the most influential figure in art photography during the close of the 19th century but from about 1900 he disappeared more or less completely from the photographic world.

Since the 1950's a select band of professional landscape photographers have been in evidence, carrying their cameras to various parts of Britain and abroad. The large format field camera came back into vogue, particularly in the production of colour transparencies for reproduction in books and magazines. 4x5 inch colour transparencies became the norm, largely at the insistence of photo engravers on large format transparencies for the printing of colour photographs. There has been a gradual swing away from this size as newer methods of colour reproduction have enabled printers to take advantage of the super sharp, fine grained pictures which could be produced on 35mm film stock. No longer does 35mm film mean

11

mushy grain, poor tonal reproduction and unsharp pictures. Only a few months before this book was written, I was told by the picture research team at Time Life Books that they preferred to select from 35mm transparencies for their excellent topographical books which sell all round the world. Other publishers have expressed agreement with this, and many of the books which I have illustrated, have used my 35mm colour transparencies for sizes up to A4 (21 x 30cm). One notable example was a vertical format book cover of near A4 size taken from the central portion of a horizontal 35mm transparency.

One professional landscape photographer I particularly admired was an unassuming New Zealander, Noel Habgood, who I first met in the 1960's. I came to know Noel and his work well, right up to his death in 1975. After a varied career as a professional musician. Noel came to Britain in 1953 to devote his life to landscape photography. An excellent lecturer and prolific exhibitor, his mastery of light and shade, and colour, was outstanding and has possibly never been equalled in this country. This verdict on his work has been confirmed to me personally by many of the publishers who used his photographs. After his death I was privileged to be asked to accept the copyright of his colour and black/white work by his next of kin, a sister in New Zealand. It is gratifying to see those photographs still appearing in books and magazines today.

Some professional landscape photographers found landscape photography a balance to their other subject interests. Notably Bill Brandt who photographed British authors and scenes evocative of their literary contributions. America produced some highly individual landscape photographers such as Ansel Adams who pioneered a zone system of exposure measurement, and father and son Edward and Brett Weston who portrayed the stark realism of the dunes of California using an 8 x 10 inch view camera, printing the negatives by contact - eschewing the loss of quality which the enlarging process produced.

This brief introduction to the history of landscape photography puts into perspective the true nature of landscape photography and its practice - a highly individual range of skills to which all good landscape photographers are constantly seeking to complement with their own artistic talents. But above all it is a special way of seeing. A blend of the senses which culminate in a conscious decision to press the camera shutter. Of paramount importance are the thoughts which lead to that decision. A limited technical skill is necessary, but of far more importance is the ordered sensitivity of the photographer's mind.

CHAPTER THREE

The Subject Matter of Landscape Photography

A dictionary definition of LANDSCAPE as a 'piece of inland scenery' is far too restricting in the photographic field. Many of the divisions in photography have somewhat artificial boundaries. I would prefer to classify a photograph as a landscape photograph if the basic emphasis is on the nature of the world about us. If people are in the scene, or buildings are obvious, it doesn't matter, provided the primary aim of the photographer has been to relate those people to their surroundings - or to juxtapose the buildings with the other elements in the picture such as sea, sky and land. Here are some comments on subjects which could appear in a landscape photograph:-

(a) Mountains and hills
 Probably the most obvious of landscape subjects and, for myself, the most pleasurable. Finding a new view of a familiar mountain, or discovering an unfamiliar range of hills must surely rank highly in life's greatest pleasures. In Britain most of the highland regions lie north and west of the imaginary line from the Wash to the Severn. Supremely photogenic are the mountains of Snowdonia, the Lake District peaks, and the highland areas of north west Scotland. I have found many excellent subjects amongst the lesser hills of the Pennines and the hills north of the Cheviots in Northumberland. Although not so grand in scale, these lesser hills can be portrayed in closer proximity to the villages in the valleys below. The limestone pavements and scars of the Yorkshire Dales have a range of shapes which record well on film. A later chapter deals more thoroughly with photography in the hills and mountains.

(b) Towns and cities
 Each town has a distinctive shape and feel about it. Starting with the setting - on a river, amongst the hills, surmounted by a castle,

surrounded by walls, rising sharply out of a lowland plain or seen from a harbour wall. Our modern towns have space and scale - much the work of the post war architects and town planners. Accept the challenge of trying to discover what visual message the designer was trying to convey. Not just the individual buildings, but the overall effect of all the styles. And towns are for people to live in, to work in and to play in. So let there be people in a busy street scene. The painter Canaletto came over to England in 1746 from his native Venice, and painted some splendid scenes of London doing just that. Although I would never suggest that photographers should copy painters, a study of painters such as Canaletto, Turner, Cotman, Joseph Wright of Derby, Paul Nash and Constable should prove interesting. There are some excellent modern illustrators whose work is almost photogenic - John Piper, David Gentleman, and Rowland Hilder.

(c) Villages

If anything is more typically British than our villages, it would be hard to imagine what it could be. Living in a village myself, I am constantly aware of the pattern of the fields which seem to underlie the pattern of life in a busy village. I am fortunate enough to live in a village set amongst hills. From all sides I can look over the village to fields which are variously green, brown, golden or white. The village nestles. Other villages I have photographed for publishers have grown along one main street - I can think of one which consisted of one street with a castle at the end of the grass verges which lined the street. Others have grown up around a village green, occasionally with the village pump well in evidence. Where there is a green, the village has a fortunate focus for its activities. Cricket, Fairs, Band Concerts - these are all part of British Village life, and just as much part of the landscape as the hills and fields.

(d) Ports and harbours

Brought up as I was within sight of the sea, it does not take much to stir in me a vision of a busy fishing harbour. One task I had to perform was to photograph the harbour at Whitby on the North Yorkshire coast. This proved a fascinating, if somewhat hazardous commission. The viewpoint I chose proved to be the best place for the fishing boats to land their catches. If I became too engrossed in the scene in front of me, baskets of fish would land dangerously near to my tripod legs. On one occasion view, camera and tripod almost disappeared over the harbour edge, only saved by a lunge to the left.

Each harbour has a different profile. Some jut out to sea as at

Seahouses in Northumberland, whilst others provide their shelter away from the harbour mouth. Many West Country harbours look good from the heights above the seafront. Particularly on the east coast of Britain, there is a sharp evening light which cuts across the harbours and ports, giving a brilliance to the colours of the boats and bringing out detail in sharp relief.

Some of the best harbours to photograph in Britain are those of the Fife coast on the Firth of Forth; Crail, Pittenweem, Anstruther, St.Monance. The other East Coast of Scotland ports from Dundee round to Inverness are also worth photographing. Further south in Britain we come across the piers which sprung up around the coast, particularly the Victorian piers of Sussex and Kent.

(e) Forests

There is a great heritage of woodlands in Britain - some of our ancient royal forests are as they existed in the 13th century. Not all our forests have been planted with an eye to the scenic - but there are some gems of 'treescapes' which add beauty to many parts of Britain. The pollarded willows in the Cotswolds and besides the Thames have shape and variety. Beechwoods are probably best known for their autumn colouring - although the light greens of spring enliven the deep shade of the forest. Trees do not grow above about 2,000 feet in Britain whereas in Switzerland, where the terrain is less exposed, they can be found up to about 8,000 feet. The most natural forests remaining in this country are the remnants of the once extensive Caledonian Forest (Scots pine and birch) in the Scottish Highlands. With about 8 per cent of our native land surface covered with woodlands, it is a subject which cannot be ignored as a landscape subject. The carpets of larch needles, the village oak trees, the spreading yew trees and the distinctive silver birches all add to the richness of our landscape.

(f) Rivers and canals

Our water system grew out of a need for power, of all sorts. Textile mills, paper mills and later hydro-electric power all shared the needs of the thirsty which our reservoirs and lakes fulfilled. Our most romantic legacy from the industrial past - the canals - with their narrow boats, flights of locks and lockside buildings, complete a scenic contribution in which water again takes a part. In fact, more and more, I have come to the conclusion that water is the lifeblood of landscape photography. In some form or other, it appears in so many photographs, bringing life and scale to an otherwise flat rendition.

Our rivers are so varied in form that a whole book could be made

out of a study of one river from source to mouth. Some of my own favourites are the Tyne and Wear, starting as they do up in the Pennine hills around Alston in Cumbria. The Tees is a most varied river - in its upper reaches it is a botanist's delight whilst its entry to the North Sea on Teeside takes place through the changing industrial landscape of Middlesbrough. Scottish rivers worth exploring are the silvery Tay and the bonny Clyde. Other favourites are the River Eden in Cumbria, the Dart, the Wye in Wales, and the Ribble Valley in Lancashire. Canals have their interesting stretches - usually accompanied by some aqueduct or bridge system. Some are in decline - there would be more except for the work of enthusiastic preservation societies.

(g) Industry

Not universally accepted as a landscape subject, it is nevertheless as much part of our scenic heritage as the classic vistas in the Wye Valley or cliffs of Dover. Man's hand on the landscape has produced such phenomena as the Cornish Alps - spoil heaps from the China Clay industry - the old smelters and spoil heaps of the lead mining industry on the Pennines, deserted mine buildings in Cornwall and Derbyshire, slate quarries of North Wales, and the old woollen and cotton mills of the north. In fact the history of our industrial past adds considerable interest to this branch of landscape photography. To be able to interpret the remains of some extractive industry, makes the whole process much more exciting. It is almost possible to bring the remains to life by means of photography.

(h) Seascapes

Back to water again. The classic photographs of the sea, with waves high above a breakwater, or pounding the bows of some trawler, have a dated air about them now. But nothing is more alive than a stirring picture of the sea. One of the main challenges of landscape photography is to convey a sense of action. To make the viewer feel he is part of a moment in time which will not be repeated. The sea has a mind of its own, and it needs patience to capture the waves at their peaks, with the sun glinting off the crest. Breakwaters and piers add shape and variety to sea pictures. I have a wonderful collection of colour transparencies of the sea breaking over the sea front at Newhaven in East Sussex. Taken from one position, each photograph is different. In fact the Sussex coast around the Beachy Head area must come high on my list of photogenic seascape subjects. The white cliffs, coupled with a stormy sky, provide a superb backdrop to the breakers on the shore.

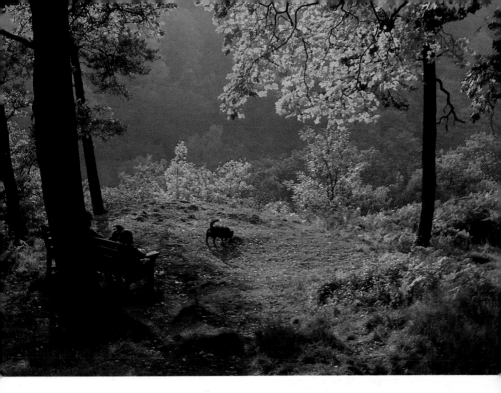

Hardcastle Crags/West Yorkshire. *Pentax
Camera. Ektachrome 64ASA film. 28-50 zoom
lens used at 50mm. 81A filter. October around
3.00pm. Exposure 1/30th at f11.*

A National Trust beauty spot, which is a blaze
of glory in the autumn. The frontal lighting
shines through the leaves at the camera -
giving a golden glow against the misty valley
behind. The family sitting by the tree added
human interest to the scene, and I waited for
the black dog to wander into the sunshine.

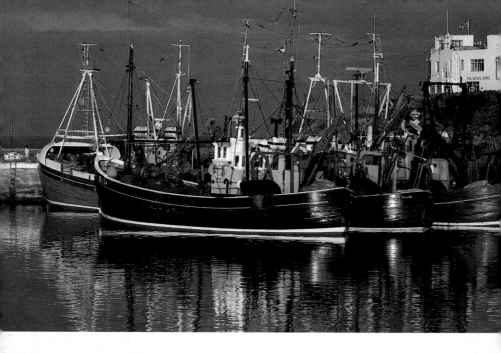

Seahouses/Northumberland. The harbour.
Pentax camera. Kodachrome 25 film. Sky filter.
28-50mm zoom lens - used at 50mm.
November around 4.30pm. Exposure 1/30th at
f11.

Whilst photographing the harbour for a
publisher, after some general views I spotted
the possibilities of a more concentrated picture
of the boats and their reflections in the water.
This part of the coast has some of the clearest
light in Britain. It comes across like a spotlight
in the evening, giving clarity and brilliance to all
the boats and harbour buildings. A real joy to
photograph.

Widdale Fell from Hawes, North Yorkshire
Pentax Camera, Kodachrome 25 film. Sky
filter. 135mm lens. November around 9.00am.
Exposure 1/60th at f11.

After a day photographing various parts of the
Yorkshire Dales for the National Park, I woke
up to find this scene only a few hundred yards
from the hotel. The mist lay over the town of
Hawes and behind it the faint outline of the
fells, still covered in snow, receded into the
picture. A study in greens and blues, with
some variations in the pattern of the sheep to
add interest.

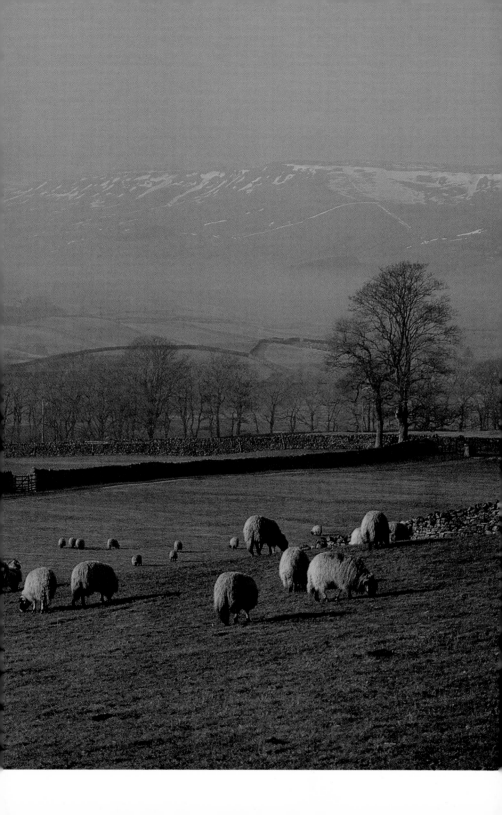

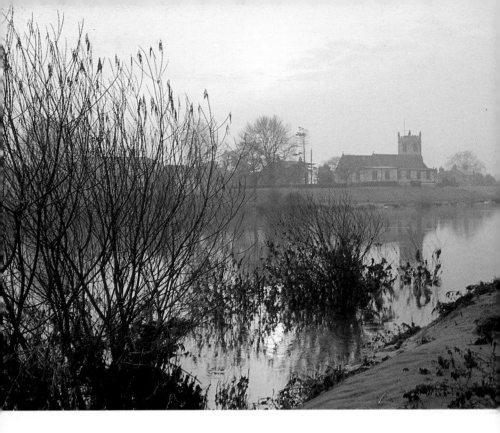

Cawood-on-Ouse/North Yorkshire. *Pentax
Camera. Ektachrome 64ASA film. 81A filter.
28-50 zoom lens used at 50mm. December
around 3.00pm. Exposure 1/30th at f8.*

The cold winter sky, and the bare foliage of the
bushes in the water, lent itself to a cold stark
treatment - the only warm touch of colour
coming from the sun's reflection in the water.
The misty background allowed the ancient
riverside church to take on an ethereal look
-almost as an afterthought to the cold winter
scene.

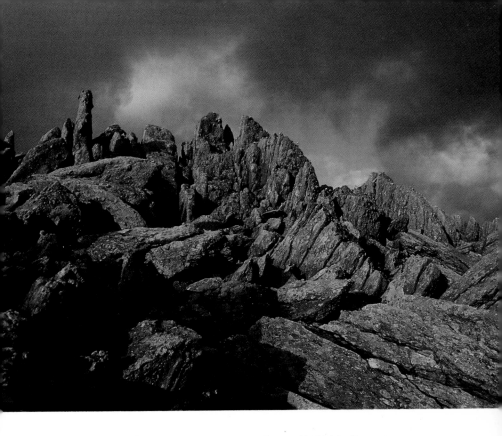

Glyder Fach, Gwynedd, Wales *Pentax camera. Ektachrome 64ASA film. 81A filter. 28-50mm zoom lens used at 28mm. October around 4.00pm. Exposure 1/60th at f8.*

The perfect lighting for capturing the drama of these rocks on the Glyders. Taken on a day out from Llyn Ogwen. After Tryfan, the sky darkened as I reached the summit of the Glyders. By patient waiting I caught the sun breaking through the clouds momentarily to concentrate interest on the highest points of the rocks, which I had positioned on the upper third left-hand side of the frame. The jagged edge to the base of the clouds, echoes the top outline of the rocks. Although a figure would have added scale, it would have spoilt the solitary majesty of the rocks - a grandeur which is independent of scale.

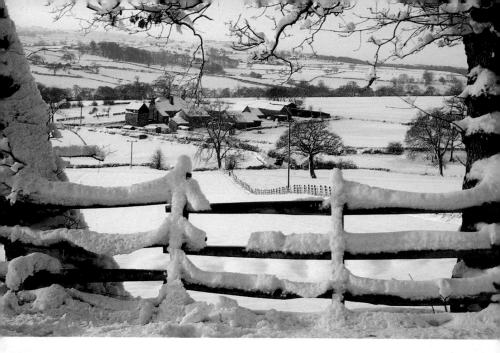

Cawthorne/South Yorkshire. *Pentax Camera.*
Ektachrome 64ASA film. 81A filter. 28-50
zoom lens used at 35mm. January around
9.00am. Exposure 1/30th at f11.

An example of photographs being on your own
doorstep. This is a view only a short distance
from my own home - and the picture was
taken en route to an assignment in Sheffield. I
have photographed this view in all weathers,
and at different times of the year. The eye runs
down to the farm in the distance - and the pink
early morning light gives the whole scene a
'birthday cake' look.

Derwentwater/Cumbria. *Pentax Camera.*
Ektachrome 64ASA film. 135mm lens. 81A
filter. August around 7.30am. Exposure
1/125th at f8.

The mist was just clearing from the lake at
Portinscale, and the hazy sun reflected from
the water between the reeds. I exposed to
produce saturation in the water and reflection,
allowing the reeds to be silhouetted by the sun,
which shone towards the camera. The haze
brought the scene into an acceptable range,
and by restricting the angle of view, I was able
to gain enough depth of field to keep most of
the reeds in focus. The calm water helped by
producing perfect reflections and no blur on the
film.

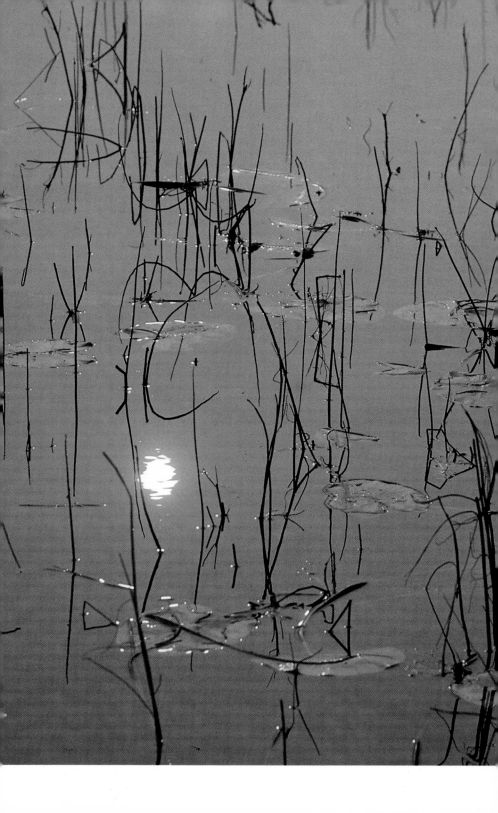

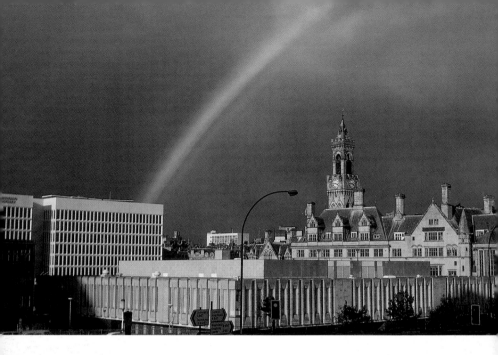

Bradford/West Yorkshire. *Pentax Camera.*
Kodachrome 25 film. 28-50 zoom lens used at
50mm. Sky filter. November, around 3.45pm.
1/30th at f16.

A chance shot taken from the steps of the
Central Library and Art Gallery - where I had
my first one man exhibition. By careful choice
of exposure - making sure not to overexpose -
I was able to capture the full colour of the rain-
bow over the Italianate City Hall.

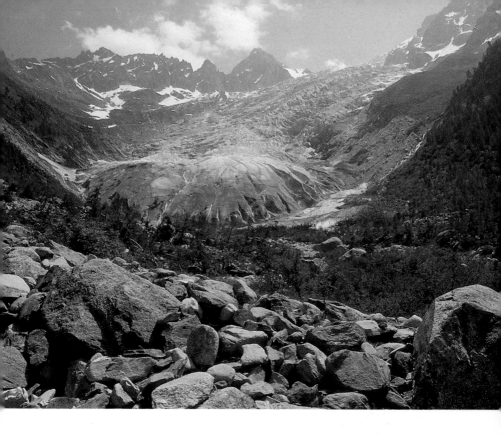

Glacier du Trient/Valais/Switzerland. *Pentax Camera. Ektachrome 64ASA film. 28-50mm zoom lens used at 28mm. 81A filter. August around 3.00pm. Exposure 1/30th at f16.*

Taken whilst leading a photographic holiday in the Vallée du Trient. As we approached nearer, the proportions of the 'pancake' shaped glacier took on a menacing look amongst the surrounding hills. I chose a wide angle lens to emphasise the foreground boulders and waited for the sun to catch the glacier, and the clouds to 'hover' over the distant peaks.

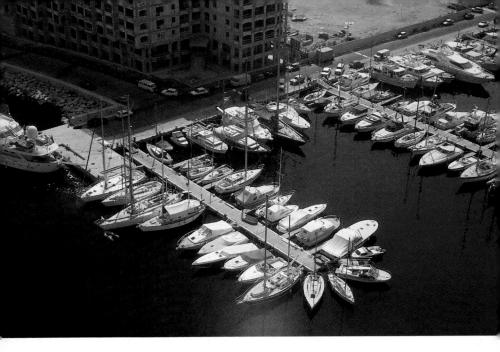

Monaco - the Harbour. *Pentax Camera.*
Ektachrome 64ASA film. 81A and polarising filters.
28-50mm zoom lens used at 35mm. August
around 2.00pm. Exposure 1/30th at f11.

Taken whilst leading a photographic holiday in
the South of France. The high afternoon sun
was shining straight down onto the boats,
creating a petal pattern of white surrounded by
a dark blue sea. By careful use of a polarising
filter, I was able to eliminate some distracting
reflections in the water, and further emphasise
the pattern of the boats. Taken from the walls
around the Rainier's Palace at Monaco.

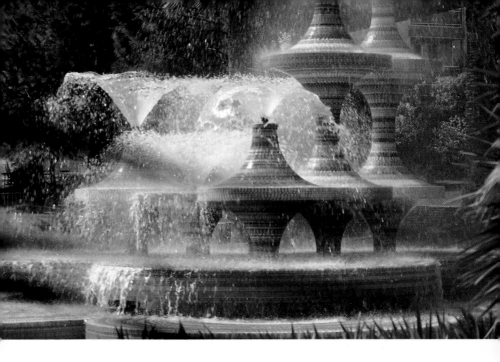

Monte Carlo/Monaco. *The Fountain. Pentax Camera. Ektachrome 64ASA film. 70-210mm zoom lens 81A filter. August around mid-day. Exposure 1/60th at f8.*

Taken whilst conducting a photographic holiday in the South of France. By using a slow shutter speed, and a long focal length setting of the zoom lens, I chose to give the water a 'fluid' look by allowing the movement of the water to trace its patterns on the film. This movement also made the background less pronounced - by virtue of the misty effect produced by the water. The out of focus leaves at the right-hand side further highlight the fountain itself.

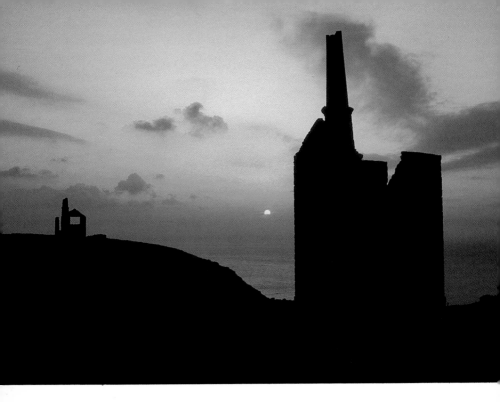

Botallack/Cornwall - Tin Mines. *Pentax camera. Ektachrome 64ASA film. 81A filter. 28-50 zoom lens used at 35mm. February around 3.00pm. Exposure 1/30th at f8.*

These dramatically placed ruins of the Cornish tin mining industry lent themselves to the bold silhouette treatment. By keeping the smaller engine house near the edge of the frame, it balanced the larger one in the foreground. I deliberately chose the exposure to render the buildings in black, giving strength to the sky-line in which the lines of the clouds converge behind the building. By waiting for the sun to be partly obscured, I was able to avoid overexposure - and a featureless sun pattern. Another shot of mine of these mines was used in the Time-Life Great Britain Book.

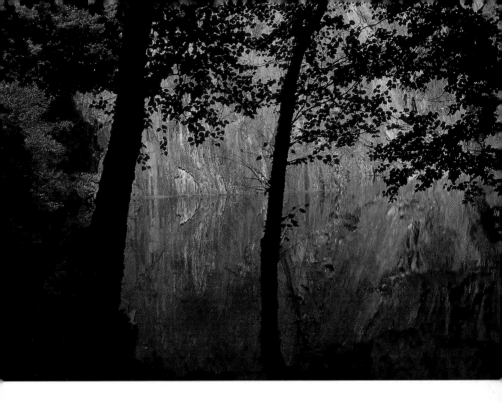

Llanberis/Gwynedd - The Vivian Quarry.
Pentax camera. Ektachrome 64ASA film. 81A filter. 28-50mm zoom lens - used at 28mm. August around 2.00pm. Exposure 1/15th at f16.

Taken whilst tutoring a course in Landscape Photography in Snowdonia. We were exploring the Llyn Padarn country park, and the fascinating remains of the old slate industry. The oldest quarry - the Vivian - had this quarry pool at the base of the workings. The quarry sides made perfect reflections in the clear, green waters of the pool. I managed to find a post to rest the camera on during the fairly long exposure needed to give sufficient depth of field to record detail over a range of distances. The black outlines of the trees - one thick, one thin, add interest to the scene.

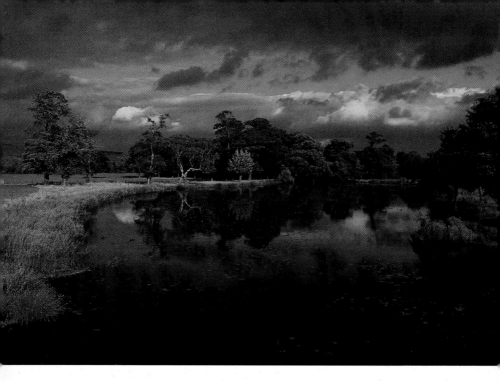

Cawthorne/South Yorkshire - Cannon Hall.
*Pentax Camera. Ektachrome 64ASA film. 81A
filter. 28-50mm zoom lens used at 35mm.
February around 3.30pm. Exposure 1/60th
f11.*

This gem in South Yorkshire - Cannon Hall - is
a Country Park which presents a different face
to the world in each season. This early
February picture was taken whilst returning
from taking a Folk Group in the hills for a record
cover. By waiting for the sun to break through
a completely dark sky, I was able to highlight
the winter colours of the reeds and bracken at
the side of the water - the River Tivy - which
flows through the park. Slight underexposure
emphasises the drama of the scene.

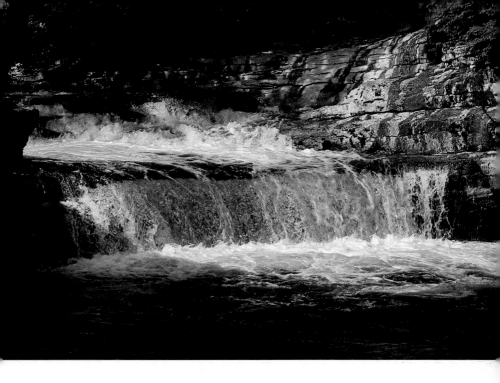

Stainforth Force/Ribblesdale/ North Yorkshire.
Pentax Camera. Ektachrome 64ASA film.
135mm lens. 81A Filter. August around
3.00pm. Exposure 1/125th at f5.6

This waterfall on the Upper Ribble is just
downstream from the packhorse bridge owned
by the National Trust - which I was photo-
graphing at the time. Cut off by the
surrounding rocks, I was fortunate to catch a
shaft of light at about 90° to the
camera/subject line. This highlighted the falling
water and gave sparkle and colour to the
scene. A long lens was essential, as the fall is
not easily accessible. By propping the camera
on a rock I was able to hold it steady, and used
a short exposure to slightly 'freeze' the water.
The water colour gave a pleasant warmth to
the force, this warm colouring being
accentuated by the dark surrounds.

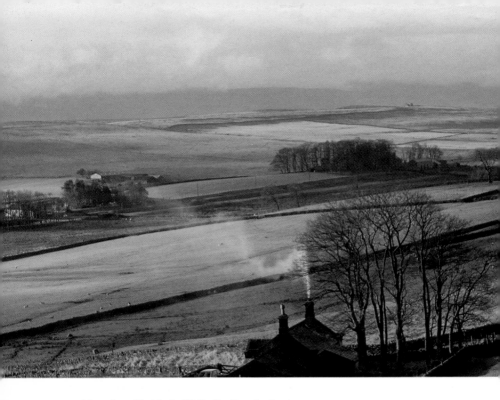

View from Hadrian's Wall - Northumberland
*Pentax camera. Ektachrome 100 ASA film.
Sky filter 70-210mm zoom lens used at
210mm. November around 9.30am. Exposure
1/60th at f11.*

Whilst photographing a 20 mile stretch of
Hadrian's Wall (on foot!) for a book on
England's Prehistory, and for English Heritage, I
looked south near Steel Rigg. The smoke which
curled from the farmhouse pointed to the Once
Brewed and Twice Brewed area. (The first is a
Youth Hostel, the second a hotel). A long lens
seemed best to compress the field patterns,
and to give prominence to the clumps of trees.
The position and scale of the tree clumps add
to the composition. The light coming from the
left of the picture emphasises the outline of the
walls and buildings - the dark grey hills and
hovering sky complete the picture.

Having spent over two years tossing around the Mediterranean on a Royal Navy destroyer, I have vivid memories of the moon's reflection across the still sea, and slightly different memories of the breakers across the bows of the ship in stormy seas. The scale of pictures at sea is so immense. This is where another ship on the horizon, or nearer, completes the shot.

(i) Snow

This is not so much a separate subject, as nature's way of providing a fresh look to familiar surroundings. The mountain which stood out against the light sky, now needs highlighting by storm clouds, or a well filtered plain sky. Filters are dealt with later in this book. The tall trees of the forest take on a mantle of glistening whiteness. Outspread branches bend nearer to the ground. The ridges of ploughed fields stand out in a pattern which narrows as it gets further from the camera. Stone walls stand above the soft snow at their base.

Whilst sunshine can bring many subjects to life, snow is certainly one of those features which can be portrayed as a tonal pattern, ranging from black through to white with greys in between. In fact many snow scenes have been taken when the snow was still falling. By choice of shutter speed, the falling snow itself can be included in the picture to give a feeling of action to the picture. The pattern traced by the falling snow is governed by several factors. The slower the shutter speed, and the longer the focal length of the lens employed, the more pronounced will be the trace of the falling snow.

This chapter lists most of the 'traditional' landscape subjects. What I wish to convey is that the subject matter can be as varied as you like. It is the approach which categorises a landscape photograph. If people are included in the scene, they are to give scale to the world around us, or perhaps to identify a locality by the occupation of the figures. Examples from my own use of figures are a line of women hoeing on the horizon in a ridged field beneath a stormy sky, a hill farmer and his dog in the distance on the Pennine Hills, a tractor catching the early morning light in the Austrian Tyrol and fellow walkers of all ages on countless hill and mountain tops. I often think it would be good to hire a large hall and invite anyone who has appeared in any of my published pictures to come along for an evening's festivities. It would make an interesting, if surprising, evening!

CHAPTER FOUR
Cameras and Film

Cameras

The most commonly asked question, and the most difficult to answer, is 'What camera do you recommend for landscape photography?'. Professionals have their individual preferences. The choice of well known landscape photographers' past and present, would cover practically every type of camera that has been made. It is interesting to list some of those cameras to give an insight into the way camera development has influenced the choice of professional landscape photographers.

Side View of Field or View Camera

Undoubtedly from the early days of the 19th century, up to the turn of the century, the large field or view camera reigned supreme. One thinks of the Abraham Brothers of Keswick who carried their plate cameras and tripods to the tops of the Lake District peaks and up many of the classic climbs. Surprisingly this type of camera, which was simply a structure capable of mounting lenses of a variety of focal lengths to make pictures on plates, sheet film, and later, on roll film back, has remained the basic tool of the professional photographer to this day. Some photographers' eyes light up at the mention of such

names as Gandolfi of London, who produced hand made wooden field cameras; Houghtons, who made Frederick Sanderson's patented movable front camera; Ross's Dry Plate cameras and Thornton Pickard of Altrincham who made triple extension Royal Rubys and half plate 'Imperial' cameras. In 1892 Arthur Newman went into partnership with a naturalised Spaniard called Guardia, and produced a range of cameras with a patented diaphragm shutter. This shutter needed no lubricant and was therefore never liable to freeze up. I once owned one of their cameras - a Baby Sibyl - and had occasion to call at Newman and Guardia's offices just off the Strand in London. Their record of camera serial numbers showed that my camera had originally been supplied for one of Sir Ernest Shackleton's Antarctic expeditions. Probably the best known official arctic expedition photographer, Herbert Ponting, also took a Newman and Guardia camera - the Universal - on Captain Scott's expedition to the South Pole in 1912.

All these cameras were designed around the large plates which were used for photography in those days. A sensitized emulsion was coated onto a sheet of glass. Frederick Archer's wet collodion process of 1851 gave way to Richard Maddox's dry plates of 1871 - enabling photographers to buy their plates boxed and labelled ready for use. Flexible film bases were introduced around 1895, and daylight loading light weight cameras became possible.

The large volume of 35mm film being produced for the cinema industry led to an interest in its use for still photography. In 1912 Oscar Barnack, a microscope designer employed by Leitz in Germany, built an unnamed prototype 35mm camera. It took until 1924 for Leitz to put a modified form of this camera into production - and the Leica was born. (Leica was short for LEItz CAmera). Other miniature cameras followed such as the Zeiss Contax, and the Kodak Retinas. All the time 35mm film was being improved, both in speed, grain and definition. Now cameras could be easily carried, taking a large number of shots on film loaded into daylight cassettes - the ideal film for the outdoor photographer.

In 1928 Franke and Heidecke put the Rolleiflex on the market - a twin lens reflex taking twelve pictures on a roll of film. Each picture was 6 x 6cm. A viewing lens of the same focal length as the taking lens, was mounted above the taking lens. This was followed in the 1930's by the development of single lens reflex (SLR) cameras such as the Hasselblad and Bronica, taking roll film. Since then there has been a continuing range of SLR miniature cameras which these days seem to come mainly from Japan. A number of landscape photographers

35mm Single Lens Reflex

Twin Lens Reflex Camera

foresaw the potential of these miniature cameras - notably W.A.Poucher and C.Douglas Milner - and undoubtedly the 35mm films available today, along with the superb lenses, make this type of camera a good first choice for landscape photography.

My own beginnings in landscape photography were with various twin lens reflexes. At various times I have owned Rolleiflexes, Yashicamats, and less well known cameras such as the French Semflex and British made Microflex. These latter two cameras have particularly good contrast lenses. The Mamiyaflex, a twin lens reflex camera with the facility of interchangeable lenses on a front panel, is also one I have used. The ability to switch to a longer or wider angle lens has been useful on occasions. I have also used a Hasselblad, a beautiful camera to own, with through the lens viewing and exposure measurement. All these cameras take roll film, normally producing 6 x 6cm negatives or transparencies. This can be useful in that some of the composition of the picture can be left till after exposure. Where I know that publishers may wish to use a picture in both horizontal and vertical formats, this is a great help - as long as I remember to compose the picture with this in mind. I also use, where conditions require it, a 4 x 5 inch field camera with various lenses. This also takes a roll film back, giving pictures 6 x 9cm on 120 roll film. But, more and more, I am coming to the conclusion that the 35mm single lens reflex camera, coupled with slow fine grained film, can produce results fully acceptable to publishers.

The speed of working, the portability, and the range of lenses available, make the SLR a good first choice for landscape photography. The manufacturers names have become household words - from Alpa to Zenith. I find the Asahi Pentax range covers everything I need, having owned several models, from the early S3 with clip on meter. Still in my possession are two Pentax Spotmatic cameras - with needle centering exposure measurement - that have travelled many thousands of miles, and ascended hundreds of thousands of feet, with me. They are still going strong. Bayonet lens fitting models such as the MX are an improvement, in that the aperture and shutter speed can be seen in the viewfinder, and the LED's (Light Emitting Diodes) which replace the needle of the Spotmatic react quicker to give a centre weighted reading. I have not yet felt the need for an automatic exposure system for landscape photography. I am constantly making conscious adjustments beyond the camera's metering, to produce the effect I want. Automation would be a complication most of the time. There is something reassuring about the simple display of a needle or LED in the viewfinder, and the knowledge that I know exactly what effect I will get from a slight shift in position of the setting. This ability comes largely from experience, but some help with this will appear in later chapters.

Side View of Standard Lens

Side View of Zoom Lens

It is an axiom that prime lenses of fixed focal length give better results than the equivalent setting on zoom lenses. In landscape photography, where wide apertures (small f numbers) are not often used the difference is marginal. In fact the ability to frame a picture accurately in the viewfinder, avoiding distracting highlights and extraneous details, contributes much to the impact of a picture. Most of my colour work is now taken on 28-50mm and 70-210mm zoom lenses. Their maximum apertures are not large, and the 70-210mm lens is bulky - an advantage when weight is required to keep the camera

steady in a high wind. For any available light journalistic work I switch to prime lenses with maximum apertures in the region of f1.4. (It was interesting to learn whilst researching this book that as early as 1925 the Ernemann works in Dresden produced an f1.8 lens for use in a plate camera.)

For black/white work I tend to use a fixed focal length lens (35mm semi wide angle) enlarging what I need from the frame to give the effect of longer focal lengths. Where a much longer lens is required I switch to a 135mm lens. The question of different focal lengths will be dealt with in greater detail later, but it is worth mentioning here that a 'normal lens' is considered to have a focal length equivalent to the diagonal of the film frame. As most 35mm photographs are enlarged, or in my case reproduced in books, to a picture ratio of 4:5, the usable part of a 35mm frame becomes 30 x 24mm, and the diagonal of this part will be $\sqrt{30^2 + 24^2}$ which equals $\sqrt{1476} = 38.4$mm. I consider the 50mm lens supplied as 'normal' with most cameras is longer than normal, and the 35mm lens I use is nearer to the true value. If necessary I can use my 28-50 zoom lens at 28mm to give a wider angle for black/white. But for reasons discussed later, I do not favour the use of extreme wide angle lenses in landscape work.

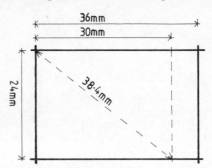

Diagonal of usable portion of 35mm Film Frame

Films

Black/white films vary in speed, spectral response, gradation and grain size. This assumes a normal developer such as ID11 (Ilford). The effect of different developers will be mentioned later. Slow films (around 50ASA) have the finest grain and are capable of more contrast and resolution than fast film (around 400 ASA). One common misconception is that a fast film should be used for the dullish light of winter. Certainly the greater contrast and brilliance

22

FILM SIZES

produced by the slower films gives brighter results, and avoids the all over dullness of some sunless winter pictures. By the same principle, the harsh summer sunlight in some parts of the world benefits from the softer rendering of faster films.

I find in Britain that a slow film of around 50ASA - e.g. Ilford Pan F or Kodak Panatomic X - provides a suitable film for all the year round landscape photography. If the lighting is particularly harsh in summer, I can use dilute development to give a softer result. Faster films give coarser grain than their slow counterparts - this shows up more in large areas of similar tone.

The choice of colour film for landscape photography is more determined by availability than processing considerations. Although it is possible to 'uprate' colour films (most commercial processors will do this for you) there is some change in colour balance, and this adds an undesired variable. These films are best used at their rate speed. My own choice for all the year round is a slow film such as Kodachrome 25 or Ektachrome 100 Professional. The Kodachrome film is process paid, in this country anyway, and as such, speed variations are not available. The Ektachrome film is non-process paid, available in sizes up to sheet film. This helps to give consistency when I am submitting a set of transparencies of different sizes to a publisher for reproduction. As with black/white films, the slower films are finer grained and capable of more brilliance than their faster counterparts.

Similar considerations apply to colour print film - slow film being my preference for landscape photography. As nearly all my colour

23

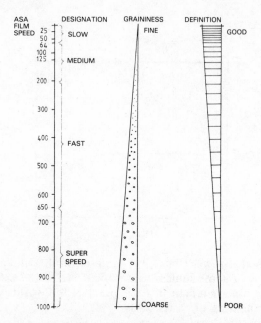

Definition and Graininess Characteristics
of Films of Different Speeds

photography is on transparency film, most of my requirements for colour prints are met by direct colour prints from the transparencies - either dye destruction materials such as Cibachrome, or reversal paper such as Kodak's R14 process on Ektachrome paper. These I leave to the skill of my processor, who does all my colour processing for me.

I do not have a regular use for Polaroid materials in either colour or black/white. Some professionals use them for assessment of colour balance and lighting, mainly under studio conditions, but outdoors this would be of limited use. It is possible to use a Polaroid back on a 4 x 5 inch field camera, producing a black/white negative as well as a print. Other films available are black/white reversal films (Agfa Dia-Direct) producing black/white transparencies, and infra-red films in both colour and black/white. These will be briefly mentioned later.

No doubt you will wish to experiment with various types of film and camera. This can be great fun. But as soon as possible settle on a simple combination of one colour transparency film and one black/white film, and get to know their characteristics and handling,

so that using them becomes an instinctive process. You may be surprised to find by some simple testing that different camera lenses give different colour renderings. Even two lenses from a manufacturer's range. Using a zoom lens keeps the colour rendering constant within a range of focal lengths. But whatever camera you choose, get to know what each lens produces and stick to as few lenses as possible. The odds against perfect colour reproduction are so great that any standardisation and simplification you can introduce will pay handsome dividends. And give you more time to enjoy your landscape photography.

CHAPTER FIVE

The Choice of Viewpoint, Lens and Focus in Landscape Photography

This chapter leads up to the most important part of the picture making process - selecting from some simple choices the best combination to give the required result. These choices start from the basic choice of viewpoint.

Despite the apparent complexity, all cameras consist of 4 basic components.

1. A means of transporting, and holding, the film in a plane at a predetermined angle to the plane of the lens. In most cameras without the swing and tilt movements usually associated with technical cameras, the film is held in a plane parallel to the plane of the lens. The 35mm single lens reflex camera is certainly based on this principle.

2. A means of holding the lens in a fixed position, normally oposite the centre point of the film frame, and a means of moving that lens, or part of the lens, forward from that position to achieve focusing of near objects. The lens should be fitted with a diaphragm i.e. a means of placing circular holes of different diameters in the path of the image forming light rays through the lens. These holes, which are usually formed by a continuously adjustable set of sliding blades, set between the components of the lens, have 3 functions:-

a. To limit the rays from the image to the central portion of the lens. In most lenses, the margins of the lens can never be as completely corrected for abberrations as the central part of the lens. The diameter of the usable part of the lens governs the maximum aperture (smaller f number) that can be used.

b. The size of the hole governs the depth of field. The smaller the hole (larger f number) the greater the depth of field. The

diaphragm does this by controlling the angle of the cone of rays from the image through the lens.

c. The amount of light passing through the lens i.e. the intensity of illumination of the image, is controlled by the size of the hole. It can thus be used to vary the intensity of the exposure just as the shutter alters it by varying the time.

3. A shutter which opens for various times - normally fractions of a second - to allow the image forming light to reach the film. The two main types of shutter are the diaphragm shutter and the focal plane shutter. The diaphragm shutter is usually incorporated in the iris mechanism of the diaphragm itself, positioned between the glass components of the lens. The focal plane shutter consists of blinds which produce a slit which travels just in front of the sensitive surface of the film. As it travels across the picture area it exposes each part of the sensitive surface in turn so that the amount of exposure each part of the film receives depends on the width of the slit, and the rate at which it travels. Most shutters of both types have T and B (Time and Bulb) setting which allow the shutter to remain completely open until closed by a second press of the exposure knob (T setting) or release of a held down exposure knob (B setting).

4. A means of viewing the picture area determined by the dimensions of the film frame, and the focal length of the lens. With simple fixed lens cameras, this is usually achieved by an optical viewfinder set above the lens. In an interchangeable lens, single lens reflex, viewing is normally by means of a movable mirror and pentaprism which gives a right way round image on a ground glass, or similar, screen - all through the lens in the camera. The twin lens reflex has a separate viewing lens, projecting an image through a mirror onto a screen on top of the camera. This image is right way up but reversed left to right. The technical camera is normally focussed onto a ground glass screen at the rear of the camera, giving an upside down, reversed image.

There are many variations, and refinements of these 4 basic components: films that move during exposure (as in a panoramic camera), double frame exposures in a stereoscopic camera, films moved by automatic winder, shift lenses on single lens reflexes (which give the effect of the rising, falling and cross fronts more usually associated with technical cameras), focal plane shutters which move vertically rather than horizontally across the frame, and viewfinder screens which incorporate a rangefinder. But in landscape photography we must keep firmly in mind that all these refinements are embellishments on the 4 basic components of a camera FILM,

LENS, SHUTTER and VIEWFINDER. And it is the choice we make in the use of the first three that decides the finished picture.

Film has already been dealt with in Chapter 4. The choice of focal length of prime, lens, or focal length setting of a zoom lens, will largely be governed by the viewpoints available to the photographer. The perspective in any photograph is independent of focal length of lens - it is produced entirely by the position taken up by the photographer. Having decided on the best viewpoint, the relative size of near and far objects is then fixed for all focal lengths of lens. The lens is then chosen to include just enough of these subjects in the picture frame. The shorter focal length lenses give a wider angle of view than the normal and telephoto lenses.

Alter the focal length of the lens and the objects grow larger but remain in the same proportion to each other.

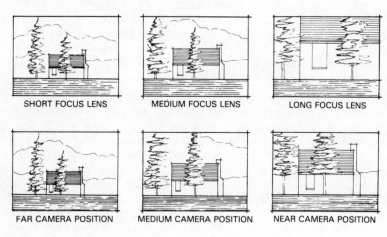

SHORT FOCUS LENS MEDIUM FOCUS LENS LONG FOCUS LENS

FAR CAMERA POSITION MEDIUM CAMERA POSITION NEAR CAMERA POSITION

Move the camera nearer, and the perspective changes.

Because of the wider angle taken in by the shorter focal length lenses, objects in the picture produce smaller images on the film than those objects taken from the same distance by normal or telephoto lenses. What tends to happen with the newcomer to wide angle photography, is that having been taught that the horizon should be above or below the centre line of the picture, he tilts the camera down to raise the horizon. (Tilting the camera up would give an overimposing area of sky, towering over small distant objects). Tilting down is all right as long as the foreground is full of visual interest - a tree, water or flowers perhaps. But nothing is worse than a large area

of uninteresting foreground. It this happens, move the viewpoint to include some foreground interest. In the choosing of a new viewpoint, remember that the foreground interest will dominate the picture in a wide angle photograph.

In the same way, using a longer focal length lens may persuade the photographer to choose a more distant viewpoint. This 'flattens' the perspective, making objects appear to be similar in size. The depth of field with these longer lenses is less than that of a normal or wide angle lens, and near objects will be more readily put out of focus. This has been used to advantage by some photographers to concentrate interest on the main part of the scene. But care must be taken when using colour. Out of focus blobs of some colours can be seriously distracting.

So the first choice for the landscape photographer is that of viewpoint. That choice could include ascending above ground level. It is amazing how different a picture can appear taken from varying heights above a field or river. I have even taken photographs with the camera almost at ground level, deliberately producing a pronounced perspective. This has turned a shingle beach into a mass of boulders. But the main reason behind selection of camera height above ground level, is to ensure that all the parts of the picture have visual interest (form, light and shade, colour). If the foreground consists of an uninteresting monotone, flat field or road, a low viewpoint will mean that this band of the picture only occupies a small area. The interest in the picture is then concentrated on the upper part of the scene, which could have an interesting sky or shapes on the horizon.

'Out of focus' areas in a picture have been mentioned above in the paragraph on longer lenses. One of the most useful functions of the camera lens is its ability to focus on objects at different distances from the camera lens. Although in theory, a lens can only produce a sharp image at one fixed distance from the lens, because the eye will accept points of light up to a certain diameter as being all points of light of unmeasurable diameter, there is a range of distances over which a camera can achieve sharp focus. These points of light grow larger the farther the objects are from the distance on which the camera is focused. This maximum acceptable diameter of a point of light is known as the *least circle of confusion,* and most camera manufacturers assume a least circle of confusion of 1/30th mm in diameter.

This consideration gives rise to a *'depth of field'* which for any given film size is affected by three factors - aperture, subject distance and focal length of lens.

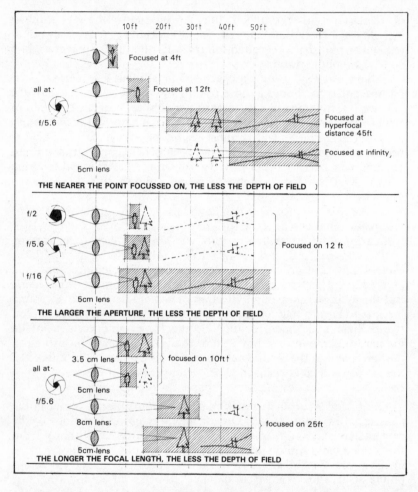

(a) Aperture - by restricting the diameter of the cone of light entering the lens, at any one focus setting the smaller apertures (larger f numbers) give a larger range of focussing distances over which detail is sharp.

(b) Subject distance - at close subject distances the depth of field is less than when focussing on a distant subject.

(c) Focal length of the lens - the longer the focal length the less the depth of field at any particular focus and aperture setting.

A depth of field scale is normally engraved on the lens.

30

One of the most useful results of the above for the landscape photographer is the concept of 'HYPERFOCAL DISTANCE'. For each aperture setting marked on the camera lens, there is a different lens focusing distance which will produce a depth of field extending from infinity back to half that focused distance. These settings give the maximum depth of field from near to infinity at that aperture setting. The smaller the aperture (larger f number) the greater this depth becomes. In practice this means that we choose an aperture which gives us sufficient depth of field to cover the distance from the nearest object required to be sharp, to the far horizon. The shutter speed to go with this aperture is then set on the camera - using a tripod if the speed is too slow for the camera to be held in the hand (slower than 1/50th second with a 50mm lens).

Differential focus i.e. making objects at some distances sharp and others unsharp, has some place in landscape photography. Normally foreground objects are rendered unsharp, as mentioned earlier in this chapter. The amount of unsharpness, and the size, shape and colour of these foreground objects is a matter of personal choice. Sometimes the unsharpness covers one corner of the film frame (e.g. flower beds) at other times the whole base or top of the frame (hedge, trees, branches) or in patches across the whole frame, with the main scene seen through an out of focus patchwork.

The variety of focusing adjustments possible with technical cameras (field or view) allows more flexibility in the use of sharp and unsharp focusing. It is not intended to go into detail about technical cameras in this book, their possibilities are largely exploited in photographing architecture and similar subjects. A mastery of landscape photography with the single lens reflex, could be followed by using that experience with a technical camera - assuming you can borrow or acquire one, and have the stamina to transport it around with you.

This chapter has outlined the choices that are available to us when using our cameras in landscape photography, and how these choices leaves us with sufficient scope to put our own interpretation on the picture we wish to produce. At the time of exposure we firstly choose the viewpoint, secondly select the lens to include what we want in the scene, and lastly decide what combination of shutter speed and aperture will give us the required focusing depth and exposure. The necessary adjustments to select what we want should become second nature, so that we can concentrate on the most pleasurable of pursuits - enjoying and composing the scene in front of us.

CHAPTER SIX

The Importance of Light in Landscape Photography

*'We all **know** what light is, but it is not easy to **tell** what it is'.*
Boswell's Life of Johnson Vol III, page 38, 10 April 1776.

There are many forms of electro-magnetic radiation encountered in nature - radio, radar, radiant heat, visible light, infra red and ultra violet rays, X-rays and the gamma rays caused by the breakdown of certain atoms. All these rays have the same velocity in a vacuum of almost exactly 3×10^8 metres per second. As for optical purposes these radiations behave like a wave motion, the radiation is associated with a definite frequency governed by the following relationship VELOCITY = FREQUENCY x WAVELENGTH. There are various units used to express the wavelength of light - the most common are the Angstrom unit $\overset{\circ}{A}$ (one ten millionth of a millimetre) and the Millimicron (one millionth of a millimetre). The Millimicron is known in the S.I. (Système International) range of units as the Nanometre (nm) and this is now the accepted unit. 1 nm = 10 Å.

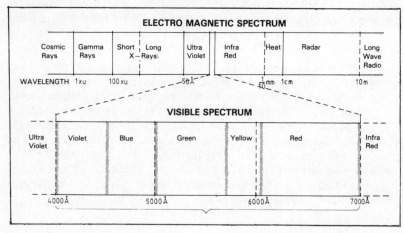

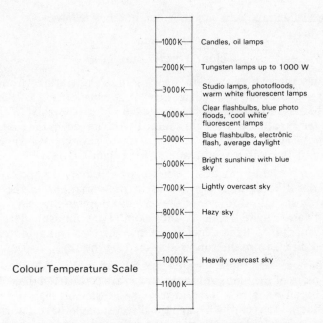

—1000 K—	Candles, oil lamps
—2000 K—	Tungsten lamps up to 1000 W
—3000 K—	Studio lamps, photofloods, warm white fluorescent lamps
—4000 K—	Clear flashbulbs, blue photo floods, 'cool white' fluorescent lamps
—5000 K—	Blue flashbulbs, electrõnic flash, average daylight
—6000 K—	Bright sunshine with blue sky
—7000 K—	Lightly overcast sky
—8000 K—	Hazy sky
—9000 K—	
—10000 K—	Heavily overcast sky
—11000 K—	

Colour Temperature Scale

Radiations in the wavelength range of approximately 400 to 700nm are emitted by luminous bodies and arouse a sensation of vision when they fall on the retina of the eye. It is this visible spectrum which has to be considered in normal photography. The colours of this spectrum are divided into bands of red, orange, yellow, green, blue, indigo and violet in that order, from violet (about 380nm) to deep red (about 700nm).

When we measure light for photographic purposes, we choose two main types of units in which to measure (a) its COLOUR or WAVELENGTH and (b) its STRENGTH or INTENSITY. In colour photography we are introduced to the concept of COLOUR TEMPERATURE as a means of expressing the colour quality of light by reference to the visual appearance of light radiated by a black body heated to different levels of incandescence. This Colour Temperature is expressed in degrees Kelvin - K - and as far as landscape photography in daylight is concerned, covers the approximate range from 4,500K (direct sunlight) to 30,000K (blue skylight). As the figures specifying the colour temperatures of the light sources used in colour photography became rather cumbersome when expressed in Kelvin degrees, an alternative scale of colour temperatures was devised. The MIRED (an acronym for Micro-Reciprocal Degree) scale is characterised by equal intervals which correspond to equal visible changes in colour. The

Mired value of a light source is measured as follows:-

$$\frac{1 \text{ million}}{\text{Colour Temperature in K}}$$

Adopting this Mired System of Colour Temperature produces a regular scale related to regular increase in blue content of the light. The effect of this is that the light balancing filters designed to alter the colour temperature of the light source before it reaches the film can be given a MIRED SHIFT VALUE (+ or −) which will apply irrespective of the colour temperature of the light source.

The important practical effects of Colour Temperature in Landscape Photography are found in the variations in the colour quality of daylight throughout the day and through the year. We talk about 'warm' light (reddish) and 'cold' light (bluish). The actual colour quality of light depends on the different amounts of light received direct from the sun or scattered by the sky.

We have all seen those rosy red sunsets and sunrises. At these times of day more of the blue light in the sun's rays is scattered than at other times, because the rays have to traverse farther through the earth's atmosphere. Objects which catch the direct sunlight have a warm cast. The sky at 180° to the sun's direction will render unnaturally blue on film, as will anything taken after sunset when the light comes only from the sky. It is worth remembering that the sun will produce a 'warm' result on film when it is less than 20° above the horizon, although the warmth will not be obvious to the eye until the sun is lower down. Daylight is at its bluest (highest colour temperature in Kelvin) when it comes entirely from a blue sky.

In black/white photography we are mainly concerned with the intensity of light, except when coloured filters are employed to translate the colour produced by light of different colour temperatures into different shades of grey.

The STRENGTH, or INTENSITY of daylight falling on a subject is measured by some form of exposure meter. These meters normally measure either the light reflected from the subject by pointing the cell of an exposure meter directly at the subject, or the incident light falling on the subject by means of a translucent cone clipped over the cell of the meter. In the latter case, the cone is pointed directly at the light source (usually the sun) from the camera position. Most Single Lens Reflex cameras with built in exposure meters measure the light reflected from the subject directly through the lens. In an automatic camera the shutter speed and/or aperture are set automatically by the

Reflected and Incident Light Exposure Meter

camera. In simpler SLR cameras a needle is centred, or a set of LED's are illuminated in turn, to give correct exposure when a certain colour is displayed, as a result of altering the exposure settings of the camera. At one time the incident light method of measuring exposure was favoured for colour photography, the photographer making allowances for the tonal range of the scene. I feel that a measurement based on the light reflected from the subject is of more use in landscape photography. Some landscape photographers use a Spot Meter (a narrow angle exposure meter) taking a reading from some small key part of the scene. If you don't have a spot meter, and own a SLR with through the lens exposure measurement, a 'spot' measurement can be obtained by fixing the longest lens you have to the camera (use a lens converter as well if you have one) and transfer the exposure reading to the camera before you switch to the lens of your choice to take the picture.

Before we leave the subject of measuring the intensity of the light, and setting the exposure on the camera, a useful rule of thumb if you find yourself without an exposure meter is to set an aperture of f16 on the camera, if it is a sunny day, away from the hours around sunset or sunrise, and use a shutter speed which is the reciprocal of the ASA speed of the film in use. For example, for a 100 ASA film set the camera to 1/100th of a second at f16, or an equivalent combination e.g. 1/200th sec at f11 or 1/50th sec at f22. If your camera doesn't have these shutter speeds, use the nearest settings. For different lighting conditions choose one stop wider (smaller number) or twice the shutter speed, for each of the following conditions;

Hazy sun, Cloudy Bright, Cloudy Dull.

For our 100 ASA film this would give us:

Clear Sun	1/100th at f16
Hazy Sun	1/100th at f11 (or 1/50th at f16)
Cloudy Bright	1/100th at f8 (or 1/25th at f16)
Cloudy Dull	1/100th at f5.6 (or 1/12th at f16)

This rule of thumb doesn't apply when the light comes from the side or back of the subject for which extra exposure is normally needed - according to the effect required. But this rule of thumb has saved the day for myself on many occasions when batteries have failed, meters disappeared over cliff edges or down potholes or when I needed to check whether a meter was working accurately. Even meters have their off days.

There have been various refinements in exposure measurement. The Ansel Adams Zone System worked on the basis of assigning tonal values to a simple scale of ten to appropriate zones in the scene. Each tone differed by exactly one f-stop from its neighbour. From a knowledge of the capability of the film to cover various brightnesses it was possible to pitch the exposure to record detail in the essential parts of the scene. In black/white photography the contrast range which the film can accommodate can be varied by altering the processing. For colour transparency film alteration of the contrast by processing is not so easy to achieve - unless you do your own processing. Each make of colour transparency film is different, but most can record detail up to a range of six zones or f-stops. So the subject and the angle of the lighting must be carefully selected to make full use of the range of the film.

The painstaking analysis needed for the Zone System is justified for the wide Californian Landscapes which Ansel Adams portrayed so beautifully on his large format camera. But for most of us on the move in the hills, or along the valleys, with a 35mm SLR in our backpack, we need to use our experience of the film's behaviour to choose viewpoints as we go along that will register the lighting characteristics of the scene; bracketing exposures around the most likely setting, usually in half stop increments, as a safeguard. Still the best way of building up experience when first starting landscape photography is to use a notebook to record the essential details of each exposure as follows:

NO. ON FILM	DAY	TIME OF DAY	LIGHTING*	CAMERA	LENS	FILM	EXPOSURE	PROCESSING

*Bright, Hazy, Cloudy, etc. The compass bearing of the view can also prove useful later.

Gradually through analysis of the results, you will get to know the best type of lighting for each subject.

There have been many attempts to define light in simple words. We have already dealt with the BRIGHTNESS and COLOUR of light. Light can also be defined as being SPECULAR (from one specific point e.g. direct sun) or DIFFUSE (from a large area e.g. a cloudy, overcast sky, or a whiteout in a snowstorm). CONTRAST is the difference between the various parts of the subject, and occurs because of the tonal characteristics of the subject and the presence of light and shade in the subject. The contrast can be local - adjacent ridges in a field, or trees in a forest, or can be considered as a total contrast of the whole range of tones. In most subjects there is a degree of ambient light - light which does not come from a primary light source, but is environmentally reflected into the shadow areas. The DIRECTION from which the light comes affects the formation of shadows, and visually conveys the shape of the landscape by means of a light and shade relationship. The direction of the light is of prime importance, and we must develop a sixth sense for the best angle of lighting to portray the essential texture, forms and space of the scene. Most camera instruction books used to tell the photographer to keep the light coming from behind the camera. It doesn't need much experiment to realise that turning to let the light come from over one shoulder or other, produces a more interesting rendering. Occasionally we may let the light come almost straight at the camera - this can be effective across water or snow. Then there is that beautiful evening light when the sun is low in the sky, and we get the sun's spotlight picking out the parts of our landscape in brilliant relief.

The study of lighting is so essential to landscape photography that this one chapter can only hope to inspire you to look at all the multitude of ways in which light affects the natural world. If you never owned a camera, this study would be the most pleasurable of experiences. There are times when I feel a privileged observer of some amazing spectral panorama. A whole book could be devoted to light in landscape photography. Cultivate the ability to look over a scene

until the various lighting elements are registered in your mind's eye. Whilst it is useful to put words to the properties of light, it helps to develop your own vocabulary to describe what you see. Or just keep the effects in your mind as a sort of bank of videos. Someone described the recession (gradual lightening of tones with distance) in a mountain scene, as the sheets of card effect. Notice how, even when there is no direct sunlight on a scene the tones pick up a complex mixture of ambient light from the surroundings. At one time no one considered a landscape photograph successful unless it had some evidence of the sun shining. Today we are attuned to images of all sorts, and we can see that even an apparently sunless landscape can show tonal differences which enliven the scene. We have come to realise that landscape photography embraces dull weather as well as fine. There are features of dull weather which can only be portrayed on film with great care. Look at the apparent overall greyness of a misty hillscape - note how the mist caps the tops of the hills with a lightness, whilst there is a progressive darkening to the bases of the hills. The fields at the bottom of the hills reflect the ambient light from the underside of the mist. By choice of viewpoint, and use of filters in black/white photography, we can create a tonal composition from the scene in front of us.

We have so far only dealt with natural daylight in this chapter on light. I have on occasion used moonlight to photograph a landscape in black/white. Pictures by moonlight call for exposures of fifteen minutes or more. During this time the moon itself moves an appreciable distance and, if included in the picture area, would come out as a blur on the print. It is possible to make two separate exposures, one for the moonlit landscape, excluding the moon, and a second for the moon itself in which the exposure is much shorter (less than 1 second of 400 ASA film). This second exposure can be on a separate piece of film and can be printed in afterwards like a cloud negative. If the moon exposure is made using a telephoto lens, it will look larger and so much more natural. The light from the moon is much weaker than daylight (the sun is about 600,000 times brighter than the full moon) and increased development of black/white film to a higher contrast is advisable. In addition to a deep lens hood to cut out the effect of strong ambient light, a piece of black card will be useful to cover the lens if any stray lights from road vehicles cross the picture area. Moonlight photography is a subject for experiment, but as a starting point use an exposure of 15 minutes at f3.5. on 125 ASA film (Black/white) with light from a full moon, keeping the moon out of the picture. For 400 ASA colour film an exposure of 4 minutes at

f3.5 will produce a sunlight effect under the same conditions. There may be some colour shift due to reciprocity law failure. (Explained more fully in chapter 8).

Fill in flash is more commonly a technique used in portraiture, but with care it is possible to highlight some foreground object in a landscape photograph by the use of flash. Care must be taken to keep the flash coming from the same direction as the sunlight for it to look natural. I have seen flash used to highlight a rose in the foreground of a field, using a low viewpoint on a dull day with stormy grey skies in the distance. By choosing a low viewpoint the effect was that of the sun breaking through the clouds and spotlighting the flower, with the rest of the scene still in shade. The exposure had to be calculated such that the distant scene had slight underexposure to create a stormy effect, whilst the flash beamed in to give lightness and brilliance to the foreground flower.

One of the best ways of learning about the use of light in landscape photography, is to pick a landscape view, ideally one which contains fields, trees, buildings, water and hills, and photograph that scene from the same viewpoint under various weather conditions, at

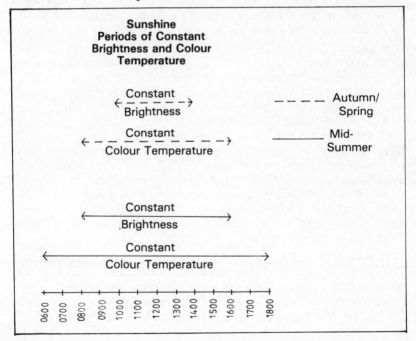

different times of the day and through the seasons. You will be surprised at the purplish-blue cast given by a heavily overcast 'snow' sky to a colour photograph. Note the textural detail brought out by a low sun, and the harsh contrast of the high suns of summer. Surprisingly the sun reaches its greatest intensity when it is 36° above the horizon, and the brightness and colour temperature (around 5,500K) then remain constant until it drops below 36°. In mid summer this 'constant' condition lasts from around 8.00 a.m. to 4.00 p.m. in western Europe and the northern United States (not allowing for daylight saving times). In spring or autumn this condition lasts from around 10.00 a.m. to 2.00 p.m. The periods of 'constant' colour temperature lasts longer than that of 'constant' brightness - about 2 hours either side. In winter the sun never reaches 36° above the horizon, and the brightness varies continually up to a maximum at noon.

The early morning and late evening light is changing continually and can be unpredictable - particularly when clouds are present. But most landscape photographers will enthusiastically speak of the excitement of these hours. Things happen quickly, and I have often broken into a gallop to reach a viewpoint in time. Once the sun is down, and twilight takes over, we can use the brighter parts of the sky to silhouette foreground subjects.

Available light is a term used to describe photography in low light conditions without supplementary lighting. In these conditions we could find ourselves recording a mixture of light sources - such as would be found in an evening shot which combined residual daylight, blue-green mercury vapour street lighting, yellow-orange sodium vapour floodlighting, green fluorescent shop lighting and reddish tungsten domestic lighting. It is possible to convert many of these lights individually to give a daylight effect, by the use of filters, but it is impossible to correct mixed lighting by filtration. All we can do is to understand the colour each type of light source produces, and contain those colours within the picture area in sensible proportions. This problem applies only to colour photography. Black/white film reacts more consistently to most light sources and they can be safely contained in any one picture.

This chapter on light contains the core of landscape photography. The keen landscape photographer is continually adding to his observations of the effects of different types of lighting on the landscape. It is a lifelong study, and one which will be repaid over and over again by the production of moving landscape photographs.

CHAPTER SEVEN

Choice of Black/White or Colour in Landscape Photography

'There is nothing ugly; I never saw an ugly thing in my life: for let the form of an object be what it may - light, shade and perspective will always make it beautiful.'

John Constable

As a professional, I am often faced with the brief of producing both black/white and colour photographs of the same subject. The publisher may want to have a choice of either for his page layouts. There have been occasions when, because a black/white photograph was not available, the publisher has converted one of my colour transparencies into black/white. It is then brought home to me how different in technique are the two processes. What was a picture with striking colour composition, looks quite ordinary in black/white. As an amateur, you may not have to photograph your landscape both ways. The choice may be one of which process will suit the subject best.

In all photography we are usually trying to convey the impression of a three dimensional object in the two dimensions of the print or transparency. The eye can be persuaded that an object is three dimensional by the skilful use of camera and lighting. In colour, we normally compose the picture to give an impression of depth by means of the colours in a scene. It is well known that the 'warmer' colours of the visible spectrum - red, orange, yellow, appear to advance towards the viewer, whilst the 'colder' colours - greens and blues - recede. If our colour picture contains near objects in warm colours (tile hung cottages, hayfields, or autumn leaves) and the distance in greens and blues (fields and sky) it will appear to have depth without recourse to the effects produced by directional lighting. Even in sunless lighting, we can convey a sense of depth in the scene. The above examples are extremely simple, and in practice, there is an interplay of colours between near and far. So our first choice for a colour picture is a range

41

of colours which together harmonise either by CONTRAST (red roofs and green fields) or ANALOGY (red roofs, pinkish walls, yellowish-brown ploughed fields). Having built up our colour relationship, we can then choose a direction of light which can bring these elements of the picture into relief, by the introduction of some shadow. Here lies the difference between a good black/white and a good colour composition. The black/white picture can be built up on light and shade alone, without consideration of the colouring of the subject - back lit ridges on a sandy beach, or black silhouettes of trees against a grey hazy distance. The colour picture survives on its combination of colours.

There are exceptions to every rule, and there have been some moving colour landscape photographs which relied on a much restricted palette - almost devoid of colour except for one small part of the scene. There have been others which relied heavily on shadow. So the choice of whether to use colour or black/white is not clearly defined. But as a general rule when you are assessing a landscape subject, for black/white think light and shade, and for colour picture it first as a range of colours, without additional lighting effects. The same subject may be suitable for both processes by changing viewpoint. Bringing the camera round to a more oblique view of the subject may produce the graphic effects of strong side lighting and heavy shadows which reproduce well in black/white. With a camera position with the sun coming from behind the camera, or slightly to one side, the same scene may spring to life as a harmonizing colour composition. If you have time, it may not be necessary to move camera position. Just wait for the sun to travel round. If there is a sky full of cumulus clouds, there could be alternating colour and black/white photographs, as the clouds cast larger and smaller shadows on the scene.

A black/white landscape composition can be built up in several ways. Unlike other branches of photography, a landscape subject does not need a strong focal point. Some very successful landscape photographs allow the eye to roam over the picture, constantly finding interesting detail, and interplay of light and shade. The 'rules' of photographic composition are nowhere more flexible than in landscape photography. At the start, we may find it useful to use certain guidelines:-

1. Keep the horizon above or below the centre line of the picture.

2. Avoid light areas trailing out of the edges of the picture.

3. If there is a strong focal point, place it away from the centre of the

INTERSECTION OF THIRDS

picture. Place it on the intersection of the thirds.

4. If there are large and small objects in the picture, the large objects will be less dominating if placed well away from the edges of the frame. Similarly the small objects can be given more prominence by placing them near the picture edge. This can be used to advantage to balance large and small objects in the picture.

5. It should be possible to choose a view point which allows near objects to register larger and darker than distant objects. This conveys a sense of depth - the eye accepts objects nearer to the camera as being darker and more distinct than the same objects in the distance. Angle of lighting helps to convey this.

6. Vanishing lines (parallel ridges in a field, or a road) should recede directly from the camera position to meet at a vanishing point within the picture frame. Roads are better portrayed in an S-shape avoiding the uninteresting shape formed by a straight road receding directly away from the camera position.

7. If there are figures in a picture, allow them space to 'move' into the picture frame. The eye normally accepts people moving from left to right, so position your figures in the left hand third of the picture area, looking towards the right.

These 'rules' of composition can apply to colour pictures as well, with the added 'rule' of 'warm' colours in the foreground, and 'cold' colours in the distance.

I have broken all these 'rules' at some time or other, and achieved publishable pictures. So never be bound by any set of rules in landscape photography. It is a sign of your maturity in photography when you break away from the established rules, and consciously compose your picture according to your own inclinations and sensitivity. But this chapter gives some guidance on the choices we make between colour and black/white in landscape photography.

43

CHAPTER EIGHT

Landscape Photography in Colour

'The purest and most throughtful minds are those which love colour the most' John Ruskin - The Stones of Venice. Vol II, chap 5, 30.

It used to be said in photography one first mastered black/white photography, and then moved on to colour photography. Undoubtedly some successful professional landscape photographers have progressed from black/white to colour - perhaps because they started in the days when most book illustration was in black/white and colour materials were not too well advanced in technique. But now that colour is being used more and more by publishers, practically all my published photographs are in colour, I feel a more logical approach is to think of black/white photography as a branch of colour photography.

When we describe colour in words we come up against tremendous personal differences in the way in which we look at colours. Not everyone understands the same thing by terms such as 'yellowish', 'pink' or 'dark red'. Terms we can use scientifically to describe colour are:-

HUE The name of a colour, defined by its dominant wavelength in the visible spectrum - blue, green, yellow, orange, red etc.

SATURATION The purity of a colour. Strong vivid colours are hightly saturated, pastel colours are desaturated due to the presence of white mixed with the colours.

LUMINANCE The brightness of the colour. This can be measured scientifically, but can appear to vary in different surroundings - light colours standing out against a black background.

It is said that we have a very inaccurate memory for colours, we tend to identify colours by comparison with charts or known objects.

Sometimes we are surprised by the colours that are shown in our colour prints and slides after processing. Luckily the viewer is not normally comparing the colour photograph with the original scene in landscape photography. We normally accept the rendering as being as natural and pleasing as we experienced at the time of taking. The odds against accurate colour photography are considerable. Colour 'seen' can be much different to colour 'measured' and recorded on film. Some differences are worth listing:

(a) Effect of light intensity on colour vision
In low light, the eye adapts to the dimness by firstly opening the iris of the eye, and adapting the retina, to increase its sensitivity. In so doing, the eye colour sensitivity alters (the Purkinje Shift) away from the red end of the spectrum towards the blue-green and eventually to zero. A similar thing happens to the shadow areas of the picture - we are less conscious of colour in these areas.

Colour film sees objectively and records the scene in its 'true' colour - or is it 'truer' than that which the eye sees?

(b) Colour under different lighting
The eye adapts to a variety of lighting and judges it to be 'white' lighting. In Chapter 6 we discussed Colour Temperature - and its variation during the day, and with different lighting conditions (overcast, blue cloudless sky etc.). Colour transparency film is balanced for a certain colour temperature of lighting (daylight film is usually balanced for 5500K). Illuminate your scene by daylight of a different colour temperature, and we find that the film cannot adapt like our eye, and will record the scene 'warmer' or 'colder' than we remembered it. Sometimes the rendering on film can be used to advantage to give a vivid sunset or a cold blue snowscape. It is possible to balance the lighting to the film's colour temperature by means of Colour Balancing Filters. The precise colour temperature of lighting can be measured with a special meter, which compares the blue and red components in light, and a filter chosen to produce the necessary MIRED shift (see chapter 6).

(c) Individual colour vision differences
Some form of defective colour vision affects about 10% of males and 0.5% of females. Uneven response to the three primary colours - red, green and blue - gives abnormal vision. At its worst green and red cannot be differentiated. Slight defects in colour vision should not seriously impair the photographer. In other ways, we view colours according to our memories and experiences which tells us how a certain colour should look. These psychological influences affect our judgement, and give us a different view of a colour photograph.

(d) Colour photography materials

Each manufacturer of colour films gives his product a range of dyes which, to the best of his technical skill, will accurately reproduce the colours of the subject. Despite this skill each make of colour film has a slight bias, and will reproduce the colours in a scene with that bias.

In chapter 6 we mentioned Reciprocity Law Failure. The Reciprocity Law states that as long as the exposure (light intensity x time) remains constant the response of the emulsion should be the same e.g. if we open up the iris diaphragm by one f-stop to double the light intensity, and halve the shutter speed, we should get the same density of image on development. This law holds for a moderate exposure range. However, long exposures to very low intensities, and short exposures to very high intensities, of lighting, produce less effect. In black/white photography this breakdown of the reciprocity law can be encountered by an increase in exposure (smaller f-numbers) and development time adjustments. However, with multi layer colour films, each layer of the film reacts differently and, whilst slight variations can be corrected by a Colour Compensating Filter on the camera lens (see below under Filters) too long an exposure may be impossible to correct by filtration. Colour film manufacturers publish recommended data for compensation of reciprocity law failure.

Despite all these difficulties which seem to beset the process of colour photography, all is not lost - and it is possible to produce beautiful colour landscape photographs. So how can this be achieved?

1. Restrict photography to the hours of constant colour temperature lighting (see chapter 6) - at least until you have built up sufficient experience to know what effect you get from the 'off peak' hours.

2. Use one colour film all the time until we get to know exactly what it can produce under different lighting conditions. Obtain information on the reciprocity law failure characteristics of the film (from the manufacturer if necessary) and expose the film within the usable range of shutter speeds. My own preference for colour transparencies is Kodak Ektachrome 100 Professional. This film comes with a printed sheet giving an exact film speed for that batch of film, along with any Colour Compensation Filter recommendations for that batch (see under filters below). On some occasions I will break my one-film rule and use Kodachrome 25 where the slow speed is no disadvantage. It reacts slightly differently to the Ektachrome film for certain applications. The Ektachrome 100 ASA film gives comparable grain and sharpness to the Kodachrome 25, with slightly brighter colour rendering under

ṣome lighting conditions. By getting to know these two films well, I can get the best out of most situations, knowing that I can rely on the skill of my processor to produce a reliable standard of colour.

In chapter 4 I mentioned that different camera lenses give different colour renderings. I recommend that you test your lenses by comparing the colour rendering of the same scene taken with the different lenses (at the same time of course) and then restrict your choice to a few lenses that come as near as possible to matching in colour rendering. At all stages in landscape photography, standardisation will pay handsome dividends.

Filters
Apart from the special effects filters which will be mentioned later, the basic range of filters which are used in colour photography fall into two categories: COLOUR BALANCING FILTERS which alter the colour temperature of the light reaching the film, and match the light to the film and COLOUR COMPENSATING FILTERS (CC Filters) which are used to correct colour shifts caused by slight differences between film batches from the manufacturer, reciprocity law failure or to correct different types of lighting (e.g. fluorescent lighting, sodium vapour). The use of CC Filters for these purposes has already been mentioned in Chapter 6 and 8.

COLOUR BALANCING FILTERS belong to a Wratten Series of which the 81 and 85 series are yellowish-brown so lower the colour temperature of the light in degrees K (warmer), and the 80 and 82 series are bluish and raise the colour temperature of the light in degrees K (colder). In practice I find the most useful filters of this range are the 81 series of 'warming' filters 81, 81A, 81B and 81C. In fact, I keep an 81A filter on my lens nearly all the time with Ektachrome 100 to reduce the tendency of that film towards a slightly blue rendering. But remember to remove the 81A in the 'warmer' lighting of late afternoon or just after sunrise. With Kodachrome 25 I find a Sky filter (1A) adequate for normal conditions. The 82, 82A, 82B and 82C range gives a colder rendering to 'overwarm' lighting. These I do not use too often.

Another most useful filter for colour photography is the Polarising Filter which gradually quenches different amounts of polarized light as it is rotated. Light is polarized outdoors by reflection from non-metallic surfaces, and from the part of a blue sky at 90° to the sun. The polarizing filter acts by eliminating reflections from water, glass & foliage. It will darken blue skies. As the effect is greatest at 90° to

the sun, take care, as uneven tone can result using a very wide-angle lens. It also has the ability to cut haze.

There is a limitless range of effects filters available, for which I find practically no use in professional landscape photography. However, if you have a taste for experimentation here is a list of some of those available.

Graduated filters.
Just over half the filter is clear, the other half gradually changes into a colour, or a neutral density. By mounting these filters, which are usually oversized squares, in slots in a rotating holder in front of the lens, the filter can be positioned to suit the scene. Probably the most useful is a neutral graduated filter, which can darken the sky to increase the colour saturation in the sky without darkening the foreground. For the best effect set the exposure without the filter in place, then position the filter to reduce the exposure over the sky area.

Star filters break up the light into small stars depending on the closeness of engraved crossed lines.

Fog filters reduce contrast and saturation of colours to give a foggy or misty effect. Can be graduated.

Prism filters produce multiple images.

Diffraction filters produce patterns based on the spectrum from light sources in the picture.

It is possible to devise your own effects filters by such trickery as smearing vaseline on plain glass, breathing on the lens, or holding a nylon stocking in front of the lens. But don't get carried away!

Colour composition was mentioned in Chapter 7. One subject which I am asked about more than ever in landscape photography, is that of correct exposure for colour transparencies. This subject starts with a choice of viewpoint which will allow you to contain the contrast of the scene within the recording range of film (about 6 f stops). No good searching for a correct exposure if the contrast is too great. It is possible to allow certain parts of the scene (slim tree branches, lines of posts) to lose detail so that at the other end of the scale the highlights will not register as clear pieces of film. If there is a danger of the sky being too light to register within the film's range, use a polarising filter to darken the sky, but watch out for uneven tone in the sky, or the loss of wanted reflections. Having contained the subject within the film's range as far as possible, measure the exposure in the normal way, bracketing either side of the value by ½ stop increments. I am assuming you are metering through the lens of your SLR camera. If

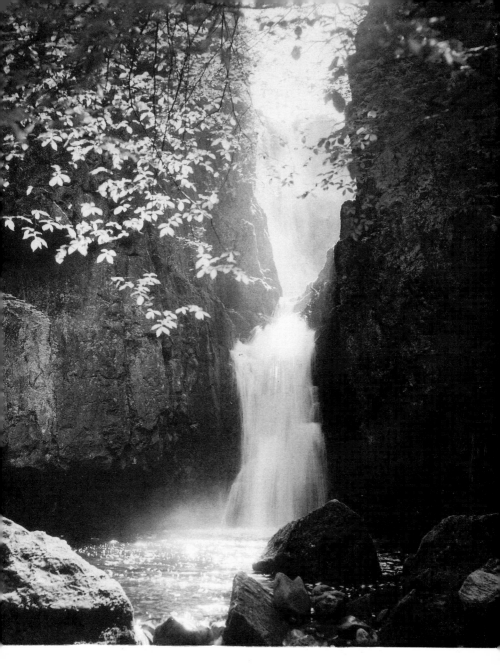

Catrigg Force, near Langcliffe, Yorkshire Dales.

Yashicamat - FP4 film. No filter

One of Yorkshire's most remote waterfalls. A slow shutter speed gave the water a silky look.

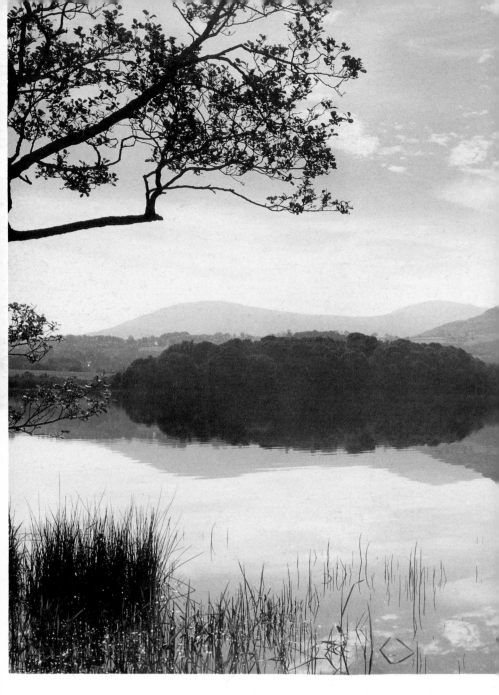

Derwentwater, from Portinscale, near Keswick, Cumbria.

Yashicamat - FP4 film, yellow green filter.

An early morning picture taking advantage of the still water to give strong reflections and tonal recession.

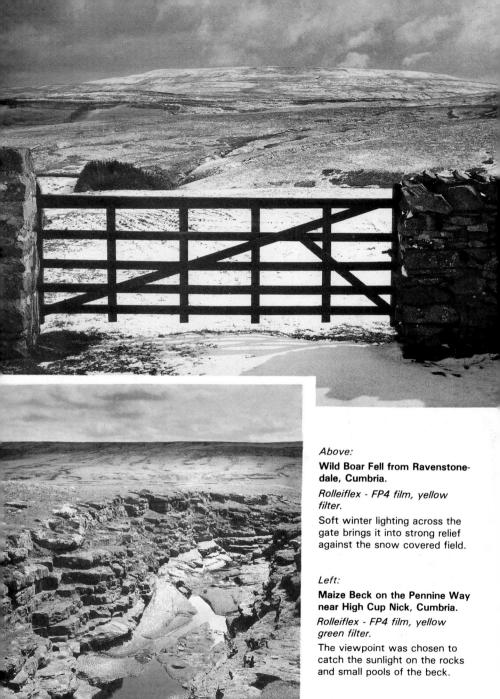

Above:

Wild Boar Fell from Ravenstone-dale, Cumbria.

Rolleiflex - FP4 film, yellow filter.

Soft winter lighting across the gate brings it into strong relief against the snow covered field.

Left:

Maize Beck on the Pennine Way near High Cup Nick, Cumbria.

Rolleiflex - FP4 film, yellow green filter.

The viewpoint was chosen to catch the sunlight on the rocks and small pools of the beck.

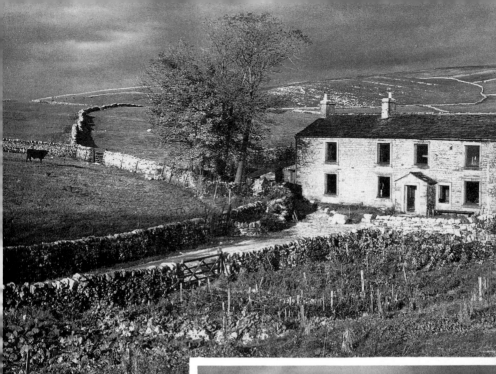

Above:

High Trenhouse Farm, Malham Moor, North Yorkshire.

Rolleiflex - FP4 film, yellow green filter.

A Yorkshire Dales farm. The stone of the farmhouse is echoed in the far hillside walls. The sky was dark with occasional patches of light. Only light filtering was necessary to bring out the tones.

Right:

Hill farmer on Murton Fell, near Appleby, Cumbria.

Rolleiflex - FP4 film, yellow green filter.

An evening picture in early summer, near High Cup Nick. The farmer and dog reminded me that work goes on even at this height.

**The Thames at Erith,
Greater London.**

Rolleiflex - FP4 film, orange filter
A winter shot on the 'business' part of
the Thames. The side-lighting, low in
the winter, catches the boats and
gives form to the clouds.

Cromer, Norfolk

Rolleiflex - FP4 film, yellow green filter.
The viewpoint was chosen to give a
strong base to the picture. The shot
was taken when the waves formed a
pattern from the base to the horizon.

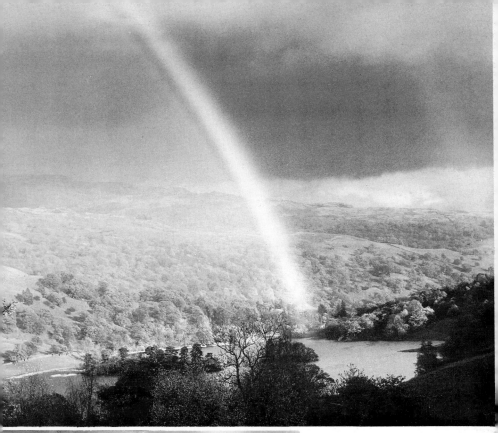

Above:

Rydal Water, Cumbria.

Mamiyaflex - 105mm lens. FP4 film, orange filter.

A chance shot from Loughrigg Terrace. The filter darkened the sky behind the rainbow, and highlighted the orange/yellow content of the rainbow.

Left:

'Haaf-nets' drying on the Solway Firth at Port Carlisle, Cumbria.

Rolleiflex - FP4 film, orange filter.

The drying nets - unique to this part of the Solway Firth - lead the eye into the low dramatic sky.

Above:

Batty Moss Viaduct, Ribblehead, North Yorkshire.

Rolleiflex - FP4 film, yellow filter.

An evening shot of a railway viaduct - the darkening skies on the right of the picture provide a natural gradation of tone throught the picture area.

Right:

Bobus and Butterley Reservoir, from Binn Moor, near Marsden, West Yorkshire.

Rolleiflex - FP4 film, yellow green filter.

A weak winter sun could be contained within the film's range without losing detail in the powder strewn hills in the distance.

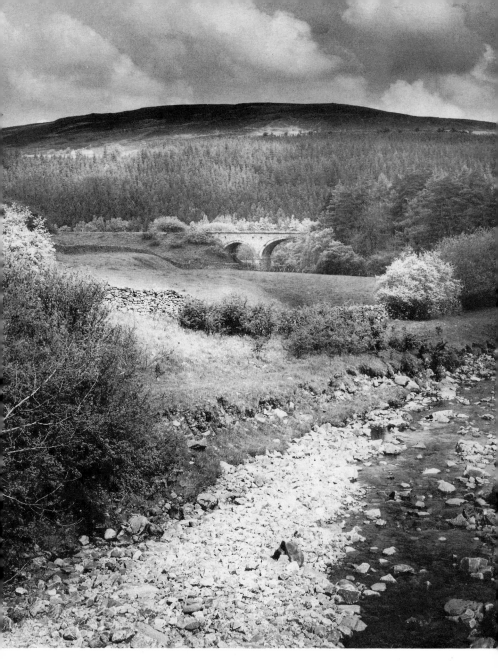

Gilderdale Burn and Ayle Common from Howgill Rigg, near Alston, Cumbria.

Yashicamat - FP4 film, yellow green filter.

An almost sunless picture with just sufficient patches of light to provide interest on the bridge of the redundant railway line.

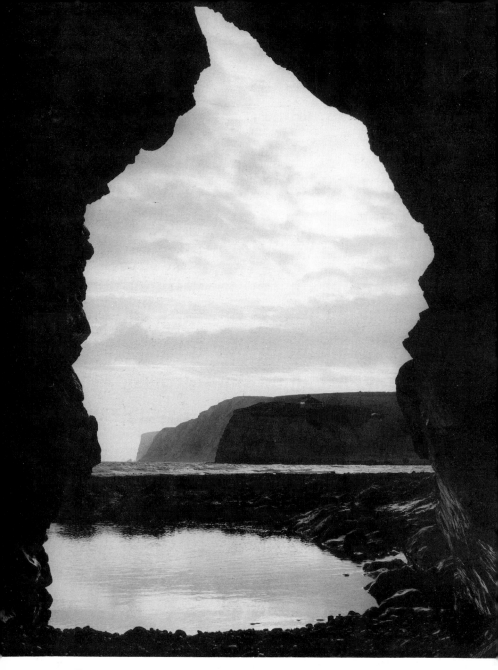

Freshwater Bay, from the caves in Arch Rock, Isle of Wight.

Rolleiflex - FP4 film, yellow green filter.
The jagged contour of the cave opening breaks away from the conventional round mouthed shape of most caves, coupled with the foreground rock.

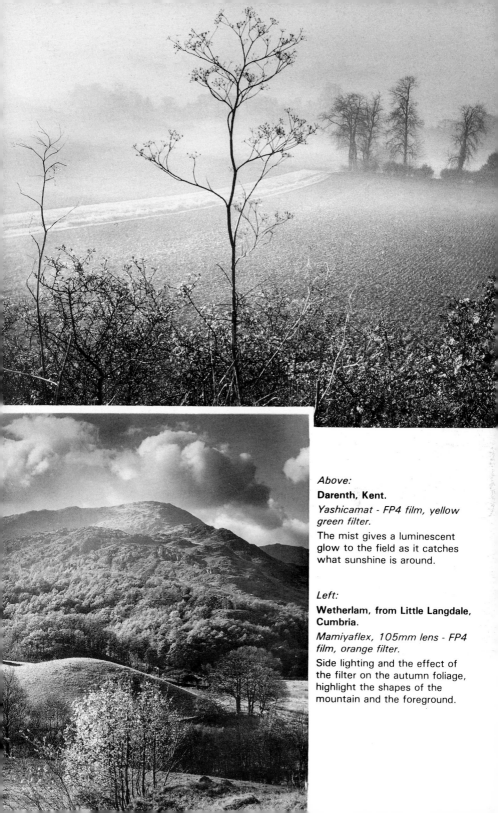

Above:

Darenth, Kent.

Yashicamat - FP4 film, yellow green filter.

The mist gives a luminescent glow to the field as it catches what sunshine is around.

Left:

Wetherlam, from Little Langdale, Cumbria.

Mamiyaflex, 105mm lens - FP4 film, orange filter.

Side lighting and the effect of the filter on the autumn foliage, highlight the shapes of the mountain and the foreground.

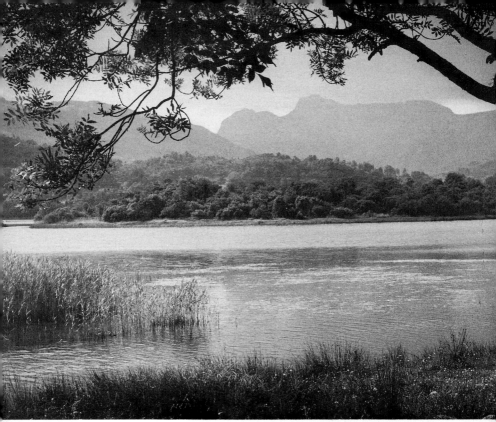

Above:

The Langdale Pikes, from Elterwater, Cumbria.

Yashicamat - FP4 film, yellow green filter.

A summer picture in which the distant haze and twinkling water creates the atmosphere.

Right:

Upper Edge from Jericho near Earl Sterndale, Derbyshire.

Rolleiflex - FP4 film, yellow green filter.

A nearly sunless picture. The lines of the walls lead through to the distant hill in a zig-zag pattern.

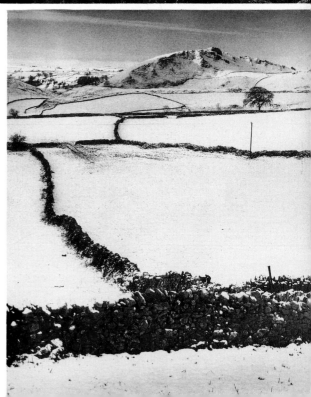

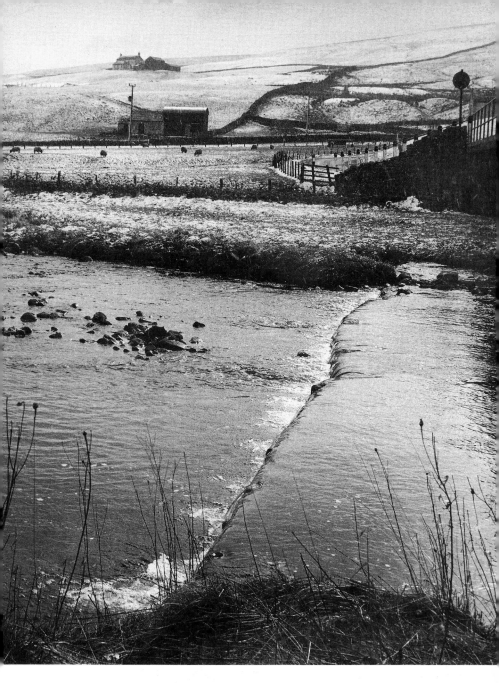

**Winter in Teesdale. Low End,
Co. Durham.**

Yashicamat - FP4 film, yellow filter.
A sunless winter shot in a lonely part
of Teesdale. It relies purely on tones.

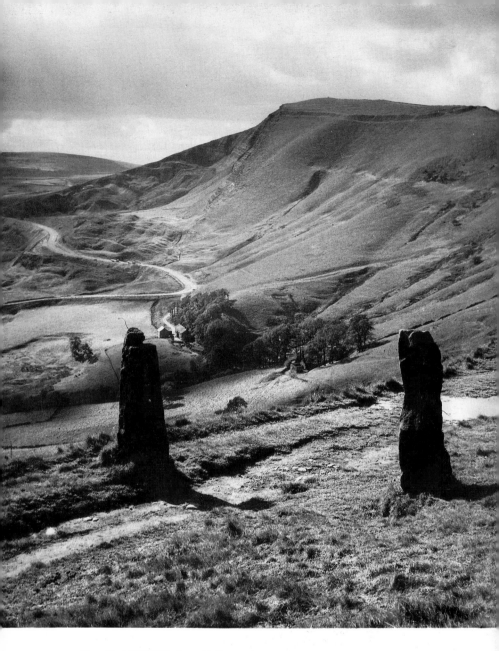

Mam Tor, (1700ft), from Hollins Cross, Derbyshire.

Rolleiflex - FP4 film, yellow green filter.

The side lighting brings the posts into relief against the background of the 'shivering mountain'.

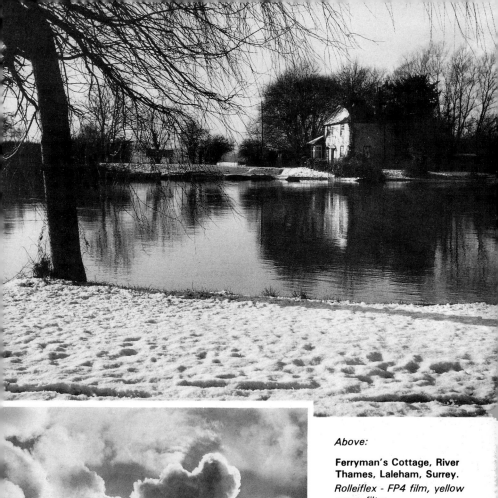

Above:

Ferryman's Cottage, River Thames, Laleham, Surrey.

Rolleiflex - FP4 film, yellow green filter.

Low winter lighting highlights the texture of the snow and catches the white fronted cottage across the water.

Left:

Styhead Tarn below Great Gable, Cumbria.

Rolleiflex - FP4 film, yellow green filter.

A wait until the light broke through the clouds above the tarn.

**Beachy Head, East Sussex.
Seven Sisters Cliffs near Birling Gap.**

Yashicamat - FP4 film. Yellow green filter.

Use of a small stop (f16) enabled sharpness from the nearby boulders to the white chalk cliffs.

you are using a separate exposure meter, remember you can place whatever filters you are using over the cell of the exposure meter to measure the exposure with the filter in place. This is as long as the filters are larger in diameter than the cell of the meter. In the case of a polarising filter, put it over the cell in the same position of rotation as you intend to use it in the camera. If you find it clumsy to be checking the position of rotation of the filter, remember that at its maximum effect the meter will show its lowest reading. So if you rotate the polarising filter in front of the cell of the meter, you can record the minimum exposure registered, and then replace the filter on the lens to give the maximum darkening effect on the sky. Whilst a range of readings from a spot meter could give greater accuracy, I find with practice and experience that the eye can judge a scene for contrast, automatically noticing over-bright highlight areas and empty shadows. A range of spot meter readings won't alter the inability of the film to cope with excess contrast! Eventually you have to choose the right viewpoint by eye. Check with a spot meter if you have one, but work towards eventually being able to judge this by eye alone. You are then starting to see colour pictures in your mind's eye. I find that most of my colour photographs are taken with a set of memorised standard exposure settings, adjusting the viewpoint to suit my knowledge of the film's contrast range. The best exposure control is the ability to move sideways!

Despite all the odds against the production of colour photographs, a mastery of the simple technical considerations of this chapter - I call them my five finger exercises - will take you on to exciting landscape photography. 'Standardise and simplify' should be your motto. Learn to judge your own results. Encouraging as it may be to have some 'expert' pronouncing words of praise over your pictures, it is your own judgments which will be of most use to you in the end.

CHAPTER NINE

Landscape Photography in Black/White

The previous chapter contains most of the basic requirements for taking good landscape photographs in colour. As mentioned in that chapter, I prefer to think of black/white photography as being a branch of colour photography. Even though we somewhat erroneously call it black/white photography (perhaps we should call it 'shades of grey' photography) we are still using light from the coloured spectrum in black/white landscape photography. We are translating these colours into various tones of grey, by means of choice of film, developer, filters and direction of lighting. We still have to consider the response of the film to light of different colour temperatures, and its reflection from coloured objects. We do not have to be so critical about matching light to film - the film can produce acceptable results within a wider range of exposures, helped along by printing papers with a range of contrasts. Black/white film reacts quite objectively to the whole process. The grains of silver halides in the black/white film do not know whether they are destined to end up in the first stage of a colour transparency, or in a black/white negative. Their reaction is the same in both cases. Black/white film usually consists of one layer of emulsion, which can be developed to produce a black/white negative. Colour film normally consists of three layers, recording the separate components of coloured light; each layer starting off as a black/white negative which is further processed to give three layers of coloured dyes. So in some ways, we can consider black/white film as being 'simplifed' colour film which responds to the visible spectrum in an order of sensitivities similar to the eye's response to light of different colours.

So once we accept that in black/white landscape photography we are still dealing with coloured light and coloured objects, we can start to approach our subjects with understanding.

Films

In chapter 4 I mentioned that my first choice for black/white landscape photography is a slow film of around 50 ASA (Ilford Pan F or Kodak Pantomic X) developed in a standard MQ and PQ Borax developer such as ID11 (Ilford) or D76 (Kodak). These films have fine grain, good resolution and are capable of high contrast by prolonged development - in some lighting conditions, contrast can be abyssmally low. Both these films are available in 35mm and 120 roll-film. Equivalent sheet films are available for the user of large format technical cameras. On a rare occasion when I have been faced with high contrast lighting, abroad in mid summer, I have used a fast film of around 400 ASA (Ilford HP5 or Kodak Tri-X) because of their ability to cope with a higher contrast, and give more shadow detail than slow film. I normally carry a supply of fast black/white films with me for photojournalism applications. However, the fast film has the disadvantage of coarser graininess despite the great strides that film manufacturers have taken to improve the graininess of fast films. It is worth noting here that when we speak of the 'graininess' of a black/white negative, we are not referring to the individual specks of silver, but to the clumps of silver which are present after development. In a fast emulsion these irregularly shaped clumps of silver are larger in size than in a slow film.

To the normal range of black/white films which end up as negatives composed of silver particles, we must add the dye image films (chromagenic) such as Ilford's XP1 and Agfa's Vario XL. These use modified colour negative technology to produce negatives of very little grain and wide speed latitude. They can be used at film speeds between 100 ASA and 1600 ASA, although the best rating is 400 ASA. These need special development, but they certainly break through the fast speed/graininess barrier of conventional black/white films, by using dyes instead of silver in the final negative. I do not find the results with these films to be any better than can be obtained with the slow black/white films, such as Pan F, which I use for most of my landscape photography. I could find more use for these films in photojournalism, where the requirements of a fast film speed for available light work normally brings with it the penalty of coarse graininess and high contrast, although there have been occasions when these characteristics of fast film have proved attractive, giving atmosphere to the shot.

In chapter 8 I deliberately ommitted to mention Infra Red Colour Slide Film (Ektachrome Infra Red) whose sensitivity is extended to include infra red light. It records living vegetation as red, depending

on the amount of infra red light reflected by the vegetation. Its use needs experimentation, and I do not feel it has a great place in landscape photography, although it could be fun to play with. Infra red black/white film is more predictable, and can produce striking results. For best results a deep red filter should be used over the lens, to cut out the lower wavelengths. Infra red film cuts through haze to give clear images of distant views. Clouds and vegetation reflect infra red strongly, and appear brilliantly white against a black sky. Infra red rays, being longer in wavelength than visible light, are brought to a focus further behind the lens - ¼% forward from the visual focus. There is a red dot engraved on the mounts of many modern lenses to indicate infra red focusing. An effect similar to black/white infra red film can be obtained by using a deep red filter and polarising filter together on slow black/white film.

Another black/white film which can be used to effect in landscape photography is Agfa Dia-Direct - a 32 ASA 35mm film with a clear base, designed for reversal processing by the manufacturer to produce 36 black/white transparencies for projection. It is possible to do your own reversal processing using special chemicals - the process takes about 40 minutes. Most useful films for this are slow films such as Pan F or Panatomic X. Other ways of producing black/white slides which I have used are:

(a). Copying black/white prints on ordinary colour transparency film using the correct lighting for the film.

(b). Printing through an enlarger, or by contact, from an ordinary black/white negative, onto a blue sensitive positive film (Fine Grain Positive). This is a bromide paper emulsion on a film base. If an enlarger is used it may prove possible to select a part of the negative for your slide. If it is impossible to achieve the necessary enlarging lens/negative distance on your enlarger, some form of extension tube may be used to hold the lens away from its normal position.

(c). Black/white negatives can be produced from your colour transparencies by copying them using a camera with extension tubes or bellows, and an attachment which holds the transparencies at the correct distance from the lens. The transparencies can then be illuminated by diffused flash or some similar light source. As if photographing an original scene, coloured filters can be mounted on the lens to modify the tonal rendering of the colours in the transparencies.

Processing

After trying almost every black/white developer ending in -lux, -phen, -ol and -al, I have come to the conclusion that as far as landscape photography is concerned, the tried and trusted Ilford ID11 and the Kodak equivalent D76, give results as good as anything else available. This section gives you the benefit of my experience with those developers. As their formulae are exactly the same, when I refer to ID11 the only significance is that alphabetically Ilford comes before Kodak. For those who like to make up their own developers, the formula is as follows:

Metol	2g
Sodium Sulphite (Anhydrous)	100g
Hydroquinone	5g
Borax	2g
Water to make	1 litre

Add the ingredients in that order, to about 750ml of warm water. Metol will not dissolve readily in a strong sulphite solution, so must be dissolved before the bulk of the sodium sulphite. As the sodium sulphite is a preservative, a *small* pinch should be added before the metol to protect against oxidation of the metol during the time it is going into solution. The additional water to make one litre can be used to adjust the temperature of the solution. Once made up the developer keeps for 6 months in a full bottle.

Used at full strength ID11 can be used to develop up to 6 - 35mm or 120 roll films per 600ml of developer, but developing times should be increased by about 10% for each successive film to achieve uniform contrast and density. I prefer to use ID11 diluted with an equal volume of water (1 + 1). This dilution gives an improvement in sharpness. The diluted developer is thrown away after use. If the subject has a particularly long brightness range (back lit subjects) further dilution will help to accommodate the subject (1 + 3). At this dilution the developer has a compensating action, bringing up shadow detail more than highlight density. Times for Ilford films at 20°C are are follows:

	Undiluted	**1 + 1**	**1 + 3**
PAN F	5½ min.	7 min.	11½ min.
FP4	6½ min.	9 min.	15 min.
HP5	8½ min.	14 min.	22 min.

These times are based on the use of a condenser type enlarger, with

negatives developed to a normal contrast.

After the developer has been poured into a spiral tank holding 8 - 36 exposure 35mm or 5 - 120 roll films, the spirals are turned continuously for 15 seconds, followed by a sharp tap to the base of the tank to dislodge any air bells that may have settled on the film. After that, the tank has one inversion agitation every minute, until the developing time is complete. The used developer is poured off and a stop bath (2½% solution of Glacial Acetic Acid in water) at the same temperature, is poured in, and the spirals continuously agitated for 2

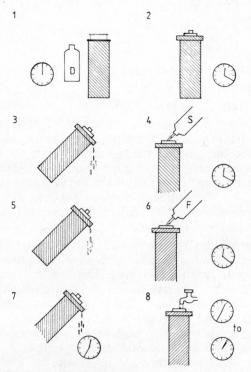

Film Development

1. Developer is added to the tank loaded with film.
2. Film is developed for the correct time.
3. Developer is poured out.
4. Stop bath is added.
5. Stop bath poured out.
6. Fixing solution poured into tank.
7. Fixer poured out.
8. Film is washed in the tank for about 30 minutes.

minutes. This stop bath is then poured away, and an acid - hardening fixer such as Ilford's Ilfofix is poured into the tank and the films fixed with intermittent agitation for 10 minutes at around 20°C. After use the fixer is filtered back into its container. The films are then washed in running, filtered, water at the same temperature as the fixer for 25 minutes. A brief rinse in water with a few drops of wetting agent (Ilfotol) and the films are dried in a dust free atmosphere for a few hours. The films are then cut into strips of six frames (35mm) or 3 frames (120 roll) and contact printed onto a 10 x 8 inch sheet of bromide paper. The contact sheets are numbered in order, and the same numbers appear on the outside of the negative bags.

Having got our negatives filed safely away into negative bags, we can then examine the contact sheets - using a magnifier if necessary. I find it helps to make the contact sheets on soft grade paper - this accommodates a wider range of tones than normal or high contrast paper - and enables us to produce images from all the frames on the film from one exposure onto the contact sheet. When examining the contact sheets we must remember that the paper was a soft grade, and make allowances for this when choosing a grade of paper for enlarging the individual frames of the film. For examination of the 35mm contact sheets, I find a piece of clear plastic scribed with a sharp point to mark out a rectangle 24mm x 30mm useful for selection of suitable frames for printing. This size rectangle has the same ratio of sides (4:5) as the 8 x 10 inch printing paper which I use for sending photographs to publishers. With the rest of the frame visible through the clear plastic surrounding the scribed rectangle, we can slide the plastic along the contact sheet until we find a frame giving us the best composition. For contact sheets from 2¼" square roll film negatives, I have another piece of clear plastic scribed to a rectangle 6cm x 4.8cm.

Enlargers consist of three basic components - a light source, a negative holder and a lens to project the image onto a baseboard holding the printing paper. The light source can be of various types but all are designed to spread the light over the negative. My own enlarger has an opal enlarger lamp and a double condenser lens which focuses a patch of light covering the enlarger lens. The negatives are held in a glassless negative holder, and enlarging lenses of 50mm and 80mm focal length are used for 35mm and 2¼" square negatives respectively. The enlarging paper is held in a frame on the baseboard of the enlarger, giving a narrow white border around the picture area.

With the negative in place, focus the required part of the picture onto a sheet of blank paper held in the frame. I firstly focus with the

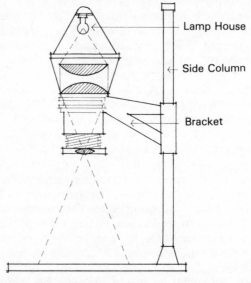

Lamp House

Side Column

Bracket

Vertical Enlarger

enlarger lens at its widest opening (smallest f number), using an enlarging magnifier consisting of a mirror and a magnifier on a stand. This selects a part of the picture area, and magnifies it until I can see the grain of the negative. Holding this focusing position, I then stop down the enlarger lens (larger f numbers) until I judge the enlarged image will give a convenient exposure time. I then check that the enlarging magnifier still shows a sharply focused image - some enlarging lenses show a marked shift in focus on stopping down. If necessary, I refocus.

There are various photometers and Cadmium Sulphide cell meters which will help to measure the required exposure and contrast grade of paper. These can be clinically accurate, but need care in interpretation of the measurements. Along with many other professionals I find the simple test strip gives as much information as I need. For a typical landscape subject of sky, middle distance and foreground, I position the test strip in the printing frame and expose successive quarters of the strip to 5, 10, 15 and 20 seconds each. This is done by covering up ¾ of the strip of paper with a black card and giving a 5 second exposure to a narrow strip which includes all the tones of the negative. The card is then moved another ¼ and given a second exposure of 5 seconds - and similarly for the other two quarters

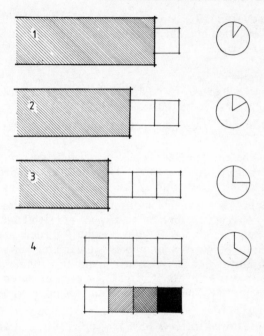

Producing a Test Strip

of the test strip. As the sky area is likely to need more exposure than the foreground, assessing the two extremes of the test strip will give a good indication of the exposures needed for the lightest and darkest parts of the picture. If the middle distance has shadow detail with the 15 second exposure, and the sky just shows tone with the 20 second exposure, as a rule of thumb we can give up to twice the exposure to the sky as that we give to the middle distance i.e. 30 seconds in this case. This allows us to print in the sky on the final print to give more emphasis, using a black card to shade the foreground and middle distance for the last 15 seconds of the 30 seconds exposure. The card should be kept on the move to avoid producing a sharp edge to the division between the sky and middle distance. I find that if the card is kept moving over a small band just below the sky area (possibly hills or mountains) the fact that the sky has been printed in is less obvious than if the card has moved in the sky itself. This can produce an unnatural effect in the form of a mid-tone area in the lower sky. Our test strip may tell us that the foreground needs 10 seconds, the middle distance 15 seconds, and the sky 20-30 seconds according to the effect required. With the black card we can move the card to shade the

foreground after 10 seconds exposure, the middle distance after a further 5 seconds and the sky can have the remainder of the 20-30 seconds to itself.

Printing Papers

Photographic papers are identified by various characteristics. The first two choices are between:

1. Fibre-based. Traditional papers with an emulsion coating on one side.
2. Resin-coated. The papers have a plastic coating applied to both sides before the emulsion. This seals the papers and allows considerable shortening of the washing and drying stages.

Most papers are available in different *weights* - at least single weight and double weight. Fibre based papers are available in these two weights, and sometimes as light weight for such uses as air mail transmission. Single weight papers were mainly intended for heat glazing to improve their finish and handling. Double weight is more expensive, but is less liable to creasing - even unglazed. Resin coated papers are normally medium weight, and are not intended for glazing.

The *surfaces* of papers vary from glossy, giving the richest looking blacks, to textured surfaces such as stipple, silk, mat and pearl. Only the glossy is intended for heat glazing.

The *colour* of the paper base can be, and most usually is, white (with fluorescent agents to aid paper brightness) or less commonly cream, ivory, brightly coloured or even metallic. The most useful base is white, but the others can be used for special effects. The emulsion itself will have a distinctive colour. The 'coldest' blacks come from a silver bromide emulsion - bromide papers are less variable in colour with different developers or development times. What were known as 'chloro-bromide' papers contained a proportion of the silver chloride used for slow speed contact papers. These contact papers are not readily available these days, but the silver chloride emulsion gives a brownish image when developed in a dilute developer. By choice of developer, dilution, and developing times, 'warm' tone blacks could be obtained. There are very few chloro-bromide papers left - the Kentona Paper made by Kentmere of Staveley, Cumbria is still available, and is worth trying for the rich tonal range it produces. Prolonged development reduces the warm tone effect - so give ample development to the print and keep development times to the minimum quoted by the manufacturer. Most of the major paper manufacturers produce standard 'bromide' enlarging papers which contain a small

proportion of chloride, giving a moderate warm tone image - less influenced by developer and development times than true chloro bromide papers.

Each paper manufacturer's papers are available in different contrast *grades*. These grades (usually numbered 0-5) enable us to match the paper grade to the contrast characteristics of the negative. A 'soft' negative (low contrast) may require a 'hard' grade of paper (high contrast - grade 4 or 5). Similarly a 'hard' negative may need a 'soft' grade of paper (grade 0 or 1). I say 'may' because you may deliberately be trying for a soft or hard effect. In that case it may be more appropriate to use the 'hardest' or 'softest' negative/paper combination to achieve the required result. Choice of paper contrast grades is very subjective - no two people always agree on the best contrast grade to choose for a given subject. Experience printing the same negative on different grades of paper will give you a guide from which to work. I use a glossy paper when sending prints to publishers - Ilford Ilfospeed or Kodak Veribrom in a range of contrasts. Although by careful control of contrast at the taking stage with the camera, followed by normal film development, I find most of my negatives print on a normal grade paper (Ilfospeed 2).

Print Developers
I do not find with current enlargement papers that different print developers can greatly influence the end result. A recent advance has been the availability of 'speed' developers -developers which give a completely developed image in around 1 minute, compared to the 2 minutes normally required. It was possible to achieve shorter developing times with conventional print developers by using them at a higher temperature than normal (75-80°F) but care has to be taken to keep all the processing liquids at those higher temperatures. A useful developer for prints which can be made up by the photographer is Ilford ID20:

Metol	3g
Sodium Sulphite (Anhydrous)	50g
Hydroquinone	12g
Sodium Carbonate (Anhydrous)	60g
Potassium Bromide	4g
Water to make	1 litre

Dilute 1 + 3 with water to make a working strength solution for bromide paper.

As with ID11 - the film developer mentioned earlier in this chapter - the ingredients should be added in the order above, to about 750ml of warm water. A *small* pinch of the sodium sulphite should be added before the metol. Metol will not dissolve readily in a strong solution of sodium sulphite. The developer will keep for 6 months in a full bottle - well stoppered. Three of the chemicals are also used for the ID11 film developer detailed in this chapter. So only two extra chemicals are needed to make up the print developer - Sodium Carbonate (anhydrous) and Potassium Bromide. The Potassium Bromide can be kept as a 10% solution in water - this will enable it to be added as 40ml of 10% solution per 1 litre of developer.

Processing the Print

The exposed print should be immersed in the developer emulsion side down, then after being fully wetted by the developer, turned over so that you can see the developing image. Rock the tray gently to agitate the solution. After about 2 minutes at a developer temperature of 20°C, or when you feel the image is sufficiently developed, lift the print out with print tongs, and allow excess solution to run off. I find bamboo tongs, with rubber tips at the end of the wooden sides, are kinder to papers which 'bruise' easily - such as the resin coated papers.

The print is then transferred either to a dish containing a stop bath - such as 3% Glacial Acetic Acid - or washed in running water at the same temperature as the developer. Stop baths act almost immediately by terminating the development of the image. In water, development carries on for some seconds. However, using a resin coated paper, there is hardly any absorption of the chemicals by the paper base, and development stops very quickly in running water. Any extra development is negligible. Fibre based papers, being more absorbent, take longer to cease development. In practice, using a developer which takes about 2 minutes to fully develop the image, the extra development which takes place with fibre based papers in running water is not important. Most landscape subjects benefit from full development, so the little extra will not go amiss.

From the stop bath, or water wash, the prints are transferred to a proprietary acid-hardening fixer - at about the same temperature as the developer and stop bath. The prints are fixed, with rocking of the dish, for 5-10 minutes according to the freshness of the fixer. I find it useful to keep my fixer made up as a 20% solution of plain Hypo (Sodium Thiosulphate Crystals). To this I add a proprietary concentrated solution of a liquid acid hardener, after diluting the 20% Hypo solution with an equal amount of water. Certain after treatments of

films and papers require a plain hypo solution as a component, so I have stock to hand. Rapid fixers such as Ilford Hypam, are available, but, as far as prints are concerned, I do not think the normal fixing time is an embarrassment. Apart from the occasional agitation of the dish, the prints do not need constant attention. Also emulsions left in rapid fixer longer than the normal fixing time could have their silver images bleached. The use of rapid fixers requires careful timing.

After fixing the papers need washing in running water at around the same temperature as the other processing solutions. The washing should be for the following times:

Single weight - Fibre based	30 mins. minimum
Double weight - Fibre based	45 mins. minimum
Resin coated papers	2-3 mins. (do not overwash).

After washing, prints are then dried either by heat glazing, or air drying fibre based papers. Resin coated papers can also be air dried naturally or by using a heated drier.

Filters

As with colour film, it is possible to alter the final result in black/white photography by placing coloured filters over the camera lens at the time of taking the picture. With colour film we are normally using filters to match the light source to the film to give as natural a result as possible. Whilst deeply coloured filters can be used to produce certain effects, the end results can look unnatural. The same filters used with black/white film would alter the relative tones in the final print, but those tones would not look unnatural. The main filters used in black/white landscape photography are as follows:

FILTER	USE	EXPOSURE INCREASE
Yellow	Darkens blue skies and lightens foliage of a yellowish colour.	1 stop
Yellow green	Similar effect to Yellow, but lightens green foliage more than Yellow. Useful for spring foliage, treescapes.	1½ stops
Orange	More pronounced darkening of skies. Lightens brickwork and Cotswold stone type buildings. Green foliage is darkened but autumn leaves register in a lightness to give great contrast.	2 stops

FILTER	USE	EXPOSURE INCREASE
Red	Considerably darkens blue skies, and produces high contrast between shadows and highlights. Can be used to produce a 'moonlight' effect in daylight.	3 stops
Polarising Filter	In conjunction with a red filter, it produces extreme contrast, almost like an infra-red effect.	Varies with rotation.
Blue	Increases the haze effect in landscape photographs by lightening skies and distance.	2 stops

*The exact exposure increase factor should be taken from the manufacturer's printed literature or leaflets.

In practice, I tend to use a yellow filter on my lens all the time. For deeper rendering of skies, or where brickwork, wood, or stone buildings are in the picture, an orange filter takes its place - but I have to be aware of the darkening effects of this filter on green foliage. On rarer occasions I will employ a red filter for a dramatic effect, particularly at sunset or sunrise.

There is a special magic about a black/white photograph which evokes an atmosphere effectively. In many ways we can manipulate black/white photographs to give all manner of meanings - darkening here, lightening there, using focus and sharpness to produce just what results we want. There is no need to apologise for a picture being only a black/white photograph - it could be better that way.

CHAPTER TEN

The Travelling Photographer - Some Practical Notes

'En largo camino paja pesa' (On a long journey, even a straw seems heavy). Spanish proverb.

In no part of landscape photography can we indulge our personal preferences more than in our modes of travel. Within limits we can choose any way to carry equipment which suits us best. Well known photographers have carried their cameras in brief cases, shopping bags, rucksacks, custom made cases, ex-army ammunition boxes, around their waist or just in their pockets. There are some excellent aluminium cases with foam inserts which can be tailored to suit the photographer's equipment. But sooner or later, one comes to the conclusion that a camera is intended to be ready for use at all times, and elaborate cases slow down the process.

I find the best method of carrying equipment is a two part system which gives cameras, lenses, films and accessories, safe passage and protection for whatever method of travel you choose to your destination. Then, having arrived at your base, allows you to carry whatever you need for each day's photography in the lightest and most accessible way.

For travel to base, rigid cases are the best answer. If you are travelling by car, weight may not be too great a consideration, and metal, or fibre cases, suitably padded with foam should protect equipment during travel. Avoid having any equipment directly on the floor of the car, or in the boot, without foam padding. The constant vibration will loosen screws. If you have no backseat passengers put your equipment cases on the backseat of the car. The cushions will support the cases without vibration. It helps to cover the cases with a car blanket, to disguise their presence, and to give some heat insulation from the sun's rays. If possible, clear colour films out of cameras before the journey - if necessary rewind 35mm films carefully into their cassettes, marking the last exposed frame number on the

film tongue. Remember when reloading the film in the camera to make blank exposures - either in the dark, or with a tight fitting lens cap over the lens. As an extra precaution I set the lens to its smallest aperture (largest f number) and fastest shutter speed to the camera, when making the blank exposures, in case the lens cap is not a perfect fit. Allow at least one blank exposure more than the frame number you recorded on the film tongue, to allow for any inaccuracy in reloading film in the camera. Do not attempt to rewind roll films onto their spools, unless you are particularly well practised in the art. They do not always like being put into reverse, and end up with folds, or worse still, light paths to the emulsion, from the poor rolling of the films onto the spools.

The main consideration for carriage of films is to keep them as cool as possible - and dry - particularly the professional colour films such as Ektachrome 100 Professional which I use. There is a variety of cool bags available in which to store the films during transit. Freezer packs containing a low temperature freezing point liquid, can be placed in the cool bags to keep the temperature down. These freezer packs, which are frozen in the ice making department of a refrigerator, are available with a flexible plastic cover. For best protection of films I have a large vacuum flask with a large mouth opening. By curving the flexible cover of the freezer pack before freezing it (tie it up with string if necessary, with a cardboard former) I can get it to rest against the inside wall of the flask. There is now space for films, previously frozen in a refrigerator, to be stored in the rest of the flask, before sealing off the opening with a large cork stopper, and screw down lid.

Another method I have used to keep colour films cool, is to obtain some large rigid polystyrene foam containers, such as the local chemist receives as packing for large bottles of liquid chemicals. These usually have a tight fitting lid of the same material. By cutting out the inside with a bread knife, it is possible to have sufficient space to hold several colour films and a freezer pack, accommodated in a plastic food box, and wrapped round with a length of white cloth. These rigid foam containers are also used for preventing vibration of cameras and equipment during transit - but make sure the containers are well cleaned out before use, and do not use any that have contained corrosive chemicals. With any form of freezing of films it is essential to have cassettes of 35mm films in moisture proof containers, and roll films in their heat sealed foil packing. After freezing allow the films to thaw out for a few hours before loading into the camera - otherwise condensation may form on the emulsion surface.

Having arrived at base, I try to find someone who will let me store

colour films in a freezer, taking them out as I require them for use. One simple precaution is to place a large piece of paper in your hotel bedroom, or wherever you are staying, on which is written 'REMEMBER FILMS IN FREEZER'. It is very easy to leave films behind when you are packing. I have had colour films posted on to me from some most unlikely places both here and abroad. When 35mm colour films have been exposed, I tear off the tongues of the films so that I cannot use them again, and replace them in their moisture proof containers ready for storage with unexposed films in the freezer. 120 roll films cannot be returned to the freezer, unless sealed against moisture. I have a small stock of those metal containers with air tight lids in which 120 roll films used to be supplied. These hold one film each and stack neatly into a freezer box. One last precaution, before use I remove all films from their cardboard boxes and put self adhesive freezer labels on the unexposed films. On these labels I write the following:

a. Type of film e.g. Ektachrome 100 - 36 exposures
b. Exact film speed of film as quoted in the manufacturer's leaflet e.g. 125ASA for Ektachrome Professional 100. This normally only applies to Professional films.
c. Date of expiry of film.
d. Unexposed.

A soft permanent marker pen can be used on roll film packets to give the same information.

When the films have been exposed I put another label on the film containers which says:

a. Type of film - as above
b. Any adjustment to rated film speed e.g. 100 ASA Ektachrome uprated to 200 ASA.
c. Exposed.

This label can either go over the original label, or replace it if the original is easily removeable. The films are now returned to the freezer to await processing.

On excursions from base, I carry enough film for the excursion. If carrying a rucksack I store colour films in the centre of the pack to avoid the sun's rays overheating the films. Black/white films need no such precautions, and as long as they are kept at a reasonable temperature throughout, will not deteriorate.

One essential on any travelling photographer's list of things to take,

Changing Bag
The front of the bag is closed with a zip fastener. Elasticated
sleeves seal off the double black fabric of the bag.

is a changing bag - a black cloth pouch with elasticated side arms, and
a means of zipping up the bag after enclosure of films or cameras.
This most useful piece of equipment will save the day if you are faced
with films jammed in cameras, film cassettes with loose end caps, or
reloading empty cassettes with bulk film. Most changing bags fold up
quite small, and can be wrapped round a small camera as protection.
On occasions when I have found myself without a changing bag, I
have improvised a changing bag from an overcoat by buttoning up the
front, inserting the camera, laying the coat flat on the ground, and
putting my hands through the arms of the coat. With care, bedclothes
on a bed can be manipulated into a temporary changing bag.
Temporary 'darkrooms' have been found in wardrobes (check the
light tightness, and if the wardrobe only opens from the outside, make
sure you have an accomplice to let you out!). Some old houses have
dark cellars: I used one at the Whernside Manor Caving Centre in
Dentdale when a camera jammed whilst on a commission for the
Sunday Telegraph Magazine. A curtained bedroom at night may give
sufficient protection, but make sure that no streetlights, or car
headlamps, shine through.

The advantage of having your films processed whilst away is
doubtful. Whenever possible I prefer to let my films go to my usual
processor who does all my films. In this country I often send films
back by post to be processed and to await my return. On rare
occasions I have had black/white films developed and contact sheets
made, by a local processor whilst away. This has happened when I
have had some doubt about a film adequately recording a subject, or

misgivings about lighting or exposure. But whenever possible I prefer to watch over my films carefully until they are safely back home, keeping them as cool and dry as possible in transit.

Lightweight tripods, telescopic or folding, can be carried on excursions without too much trouble. For a lot of shots I find I can use some available support such as fence, gates, stones or a tree trunk to hold the camera steady. By careful manipulation it is possible to take quite long exposures this way. Some photographers carry a bean bag with them to cushion variations in supporting surfaces. I have used a companion's shoulders, or head, as a rest for my arms during exposure, or jammed my arm up against a door frame or wall to give rigidity to the arm. Even without a support I find I can take fairly long hand held exposures by following one or two rules - breathe steadily whilst pressing the shutter (holding your breath produces a tension which can affect the smoothness of the shutter release); pull the strap of your camera case tightly under your armpit so that the camera is held tightly against one eye; if your camera has a delayed action shutter release the use of the delayed action produces a shutter release without finger pressure at the time of exposure.

Always carry spare batteries for cameras, meters, or other accessories which need them. As a first aid measure, memorise the simple method of calculating daylight exposures oulined in Chapter 6 i.e. for an average subject in sunshine from 4 hours after sunrise to 4 hours before sunrise, from spring through to autumn, expose at

$$\frac{1}{\text{film speed in ASA}} \quad \text{at f16}$$

At all times aim for lightness. One camera around the neck on a short strap, and another camera and extra lenses in a rucksack. Filters, one or two spare films, and any small accessories are probably best stored in the outer pockets of a jacket, readily to hand. Shoulder bags can be useful for low level excursions, but I find them cumbersome on more energetic hikes on the hills. As with all cameras and equipment, the lighter the colour of cases and bags the more they will reflect heat and keep the contents cool. In use, the cameras can be covered with a white handkerchief or similar cloth when in direct sunshine for any length of time.

Restrictions on taking photographs outdoors are not likely to be too much of a problem - unless you are photographing some security classified installation. Some public parks have regulations about use of tripods, flash and heavy equipment. If you wish to trespass on someone's property to get the angle you want, ask permission first and

explain for what purpose you wish to take the photograph. If people appear in your photographs, you can normally have that photograph published in a book or magazine, without permission from the people concerned, provided you have not invaded privacy or represented the people in a libellous way. A street scene taken from the Queen's Highway should be publishable without extra permission. It would be somewhat difficult to trace everyone in a busy High Street! In some foreign countries there are special restrictions - for instance photographing women in some Muslim countries. In these countries, seek advice from the local police or an embassy regarding the position. I find that if in addition to any legal restrictions, you treat your subjects with consideration and respect, you will be able to carry out your photography with no real problems. Most people like to be photographed if it is done in a courteous way.

Whenever travel is involved, make sure your equipment is well covered by an insurance policy which includes car and air travel. Some insurers have restrictions on photographic equipment during travel, so make sure you read the policy carefully.

X ray devices used at airports can affect unprocessed film. The only safe way is to pack film in hand baggage and ask for manual inspection. If it is possible to send films home by post within a reasonable time, this might be an easier way to deal with this problem.

The joys of travel with a camera are so great, that none of the restrictions mentioned above should spoil the pleasure and excitement of visiting a new country, or climbing another mountain. Common sense or courtesy will see you through most difficulties, and leave you to enjoy the exhilaration of crossing the next frontier.

'If you look like your passport photo, in all probability you need the journey'. Earl Wilson - American Columnist, Ladies Home Journal 1961.

CHAPTER ELEVEN

A Camera in the Hills and Mountains

'Night's candles are burnt out, and jocund day
Stands tiptoe on the misty mountain tops'
Shakespeare - Romeo and Juliet, Act ii V9

For many landscape photographers, the subject matter supreme above all others is the photography of mountains. Fortunately for those who do not feel they can scale the highest peaks, some of the best photographs of mountains are taken from half way up the other side of the valley, or even from the valley bottom itself. Certainly there is a sense of achievement in reaching the top of a mountain, but at this height it is not always easy to convey the scale and size of the mountain, or its surrounding peaks. So this chapter is not directed purely at the rock climber, but should be of interest to anyone who has a love of the mountains - even if that interest is mainly directed towards gazing upwards at the finest hills.

Equipment

The type of camera you take on the hills can be the same as you use for the rest of your landscape photography. There is, of course, a special requirement to keep all mountain equipment to the lightest possible, particularly if you are travelling great distances or to great heights. I have carried various cameras up to the tops - a large plate camera and tripod once went to the summit of Snowdon with me (not by the railway either!). But for most purposes a 35mm SLR will fit the bill.

I take two Pentax bodies - one loaded with slow speed colour transparency film and the other loaded with a similar speed black/white film. As a precaution, I also carry an extremely light Kodak Retina 35mm folding camera, with a fixed lens. If one of the Pentax bodies develops troubles, I have a second string to my bow. On the rare occasions when this has happened, I used the Retina for black/white, knowing that I can selectively enlarge from the film frame if necessary, to give the same result as a telephoto lens. At one time I carried an armoury of lenses for the Pentaxes, but for colour I now restrict myself to 28-50mm and 70-120mm zoom lenses which can

be used with either camera body. For most of the journey, I have the 28-50mm zoom lens on the body which contains colour transparency film (usually Ektachrome 100 or Kodachrome 25). I find most of my colour pictures in the hills are taken at a focal length setting of 40mm on the zoom lens, the extreme wide angle and telephoto settings should be used with care. As a general rule the standard focal length lens (I consider a 'standard' lens for a 35mm camera should be around 40mm for reasons explained in Chapter 4) gives the most natural rendering. On the black/white Pentax body I have my usual 35mm lens in place. All lenses are useable on both camera bodies. Cameras and lenses taken on the hills should have sturdy cases for protection against the elements. I also take a supply of sturdy plastic bags of various sizes (with wire ties) in case a camera case front disappears over a rock edge, or just to store films. In poor weather conditions all sorts of accidents can occur, and the humble plastic bag can save the day.

In addition to cameras and lenses, I carry a small range of filters e.g. Sky 1A (for Kodachrome); 81A, and 1B (for Ektachrome 100); Polarising (for colour and black/white). Yellow; Orange; and Red. A set of extension tubes for close-up work on flowers or insects, lens hoods, a hand held exposure meter, a small folding tripod, a cable release and the ever present changing bag complete the contents of my rucksack.

Before departure I clean the rear and front surfaces of all lenses with a blower brush followed by a gentle clean with a lens tissue and lens cleaning fluid. A soft, well washed, handkerchief can be used instead of the lens tissue if necessary. Do not 'scrub' the lens surfaces.

Filters are also cleaned carefully on both surfaces, and for the colour camera a 81A is usually left in place on the lens when using Ektachrome 100 film (or Sky 1A for Kodachrome 25). A 2x Yellow filter is kept in place on the black/white camera. These filters give protection for the lens surface, and can be more readily cleaned than the lens itself. The spare filters are kept in circular plastic screw cases, although some photographers prefer the stack-cap system in which filters are screwed together to form a unit with screw on 'lens caps' on the ends of the unit. I prefer to have my filters in separate plastic cases, clearly labelled with the type of filter, screw size, and exposure factor e.g. Yellow, 49mm, + 1 stop. If you have lenses taking filters of different sizes, it is possible to get stepping rings which screw on to the front of the lens to accept filters of a different size to the lens mount. This enables one set of filters to fit different lenses. If you want to take any special effects filters such as the graduated over size

square types, you will need a special slotted adaptor which fits in front of the camera lens. This adaptor is sold by the filter manufacturer. I would not put special effects filters high on my priority list for mountain photography - there are enough natural special effects in the high hills.

Whenever possible I keep the two Pentax cameras around my neck, on short straps, ready for use. Everything else is either stored in my rucksack or in the pockets of my outdoor clothing.

Lighting and Exposure

The most generally useful lighting for mountains is side-lighting. This lighting brings out the texture and contours, and combined with some atmospheric haze to give an impression of depth, will bring out the 'feel' of the mountains. This type of lighting is essential in black/white photography, for it is only by the variations in tone that we can portray the depth and scale of the mountains. For best effect the foreground tone should be as dark as possible, the remaining mountain planes going progressively lighter to the most distant peaks. To preserve this 'recession' of tones, I would normally recommend a moderate filter, like a 2X yellow. A deeper filter will overdarken the distant hills. Only where there is considerable haze present, would I recommend an orange or red filter - these filters penetrate haze more effectively. In colour, we have less control over the tonal values, although a polarising filter, combined with side lighting will bring out the saturation of colours, and deepen the sky but beware of the uneven tone resulting from the use of wide-angle lenses with a polarising filter. Lighting from behind the camera may be acceptable for colour photography, reducing the contrast range and producing a sense of depth from changes in colour from foreground to background. I personally prefer some shadow, even in a colour transparency.

Back lighting from a high sun can produce dramatic effects, from the great contrast between each plane. These planes become largely featureless masses, devoid of detail. By careful choice of viewpoint this type of photograph can be effective - particularly if there is water in the scene. Back lighting is more suitable for black/white, but would need careful manipulation in colour. The very high midday sun in summer can be useful for photographing north facing slopes - which are normally in shadow.

Exposure for a normal mountain subject, in side or front lighting, should give no problem. The indicated exposure on your through the lens, or hand held, exposure meter, should be accurate enough for

colour or black/white. If in doubt, bracket your indicated exposure by ½ stop either side. If you are using back lighting, make sure the sun does not shine directly into the camera lens - if necessary shade the lens with your hand over the top, and point the camera or meter down slightly when setting the exposure. Some lenses have built in lens hoods, if not fit one to your camera for this type of lighting. I am a little careless about fitting a lens hood to my lenses for front or moderate side lighting. I have acquired a technique of shading the lens from the sun's rays by the judicious positioning of an open hand out of the field of view. If you are not an expert enough juggler to lose one hand from the camera, fit a lens hood to your camera lens, or get an accomplice to hold something in the right position for you.

If your exposure reading takes in a snow covered expanse, you must remember that a reflected light exposure meter assumes the tones in a subject average to give a mid grey. So give one more stop exposure for a landscape picture to retore the snow to a whiteness. Similarly, if you are taking a photograph in mist or clouds, give one or two stops over exposure to compensate for the reflected light which abounds.

High Altitude
A consideration when taking photographs at high altitude is the considerable amount of ultraviolet radiation which is present because of the lower thickness of atmosphere which normally screens the rays of the sun. This will register on colour film as blue. A strong UV filter on the lens will eliminate this. 1A and 81A filters absorb some UV radiation, but if in doubt add a UV filter as well.

The other consideration at altitude is the increase in local contrast, due to less scattering of reflected light into shadow areas. The skylight is a much deeper blue, and in black/white photographs, any colour filter added will have a more marked effect on contrast than at lower altitudes, rendering the sky almost black.

Time of Day
Out on the hills, on the move, we try to take photographs throughout the day. But undoubtedly the most interesting lighting effects come when the light is low, bringing the mountains into relief.

In Chapter 6 we discussed the different qualities of light at different times of the day - in particular the hours just after sunrise and just before sunset. In mountain areas, some preliminary research is essential to discover the times of day when the shadows cast by the mountains put the valley bottoms into darkness. This produces contrast problems.

Composition
In Chapter 7 I outlined several guidelines for composition in landscape photography. These could be applied to the photography of hills and mountains. I might add that if our mountains form a triangular shape with the apex offset to left or right of centre, this will produce a pleasing effect. However, as most readers know, each range of hills or mountains have a distinctive shape - they weren't all formed as offset triangles! So we must choose from our experience of shapes, tones, perspective, contrast and colour the best balance which will convey our view of the peaks. There are certain classic views of the mountains of the world and a study of illustrated books on those areas will familiarise you with the best loved profiles of peaks such as Tryfan in Snowdonia, Schiehallion in Scotland, Mam Tor in the Peak District, Mont Blanc in France, Pen-y-Ghent in the Yorkshire Dales or the Dolomites in Italy. But there are other viewpoints which say to the photographer - I never thought of taking it from there, or taking it that way. So follow the light, and follow the weather, to create many many pictures from the hills and mountains.